The Campus History Series

FRANKLIN & MARSHALL COLLEGE

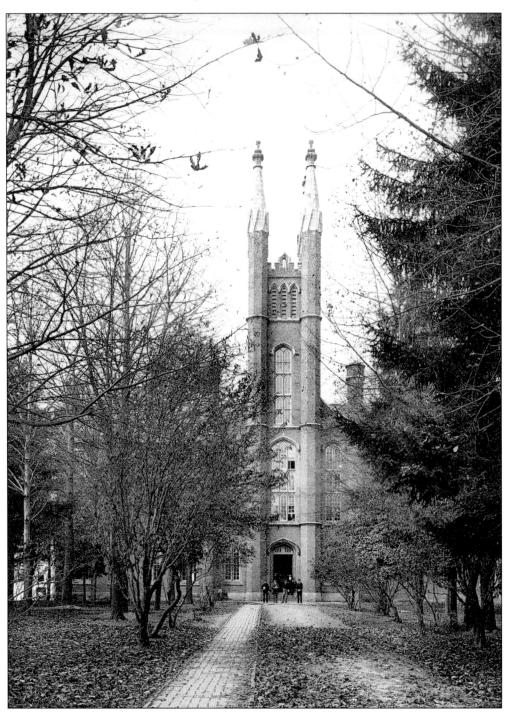

This photograph of the College Building was published in William Mann Irvine and Harry Nelson Bassler's *Views of Franklin and Marshall College* (1892). By the 1890s, the original building on campus was also called Recitation Hall, as it was in the original caption to this photograph. Old Main became its familiar name after the dedication of the Science Building in 1902.

The Campus History Series

FRANKLIN & MARSHALL COLLEGE

DAVID SCHUYLER AND JANE A. BEE

ARCADIA
PUBLISHING

Published by Arcadia Publishing,
Charleston, South Carolina

Printed in the United States of America

Library of Congress Catalog Card Number: 2004107291

For all general information, contact Arcadia Publishing:
Telephone 843-853-2070
Fax 843-853-0044
E-mail sales@arcadiapublishing.com
For customer service and orders:
Toll-free 1-888-313-2665

Visit us on the Internet at www.arcadiapublishing.com

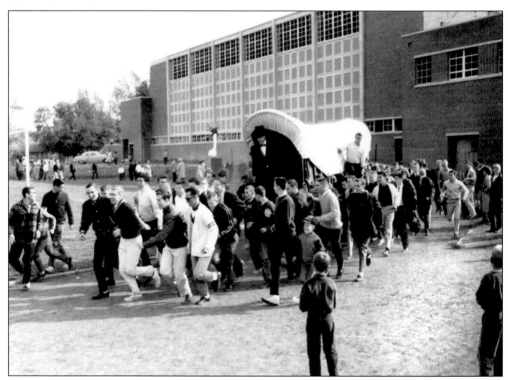

First-year students pull the college's Conestoga wagon around Williamson Field
c. 1962. This was a homecoming ritual for a number of years. The wagon was a gift to
the college by Alpha Delta Sigma, the professional advertising fraternity. Through gifts
by the class of 2000 and Richard J. Waitneight, class of 1960, the wagon was restored
and rededicated in 2002.

CONTENTS

ACKNOWLEDGMENTS

We are indebted to many people for their help in making this book possible. First, we are grateful to the alumni, faculty, administrators, staff, and friends of the college who have donated photographs and other memorabilia. In preparing this book, we have been able to draw upon the scholarship of these earlier historians of the college: Joseph H. Dubbs, H. M. J. Klein, Frederic S. Klein, and John A. Andrew III. We are especially indebted to Sally Foreman Griffith, who is completing a comprehensive and truly extraordinary history of Franklin & Marshall. Sally made the fruits of her research available to us, patiently answered innumerable questions, and offered ideas and suggestions that we invariably found helpful.

Three other people were indispensable to our efforts. College archivists Christopher Raab and Michael Lear gave us the benefit of their knowledge of Franklin & Marshall's archival collections and were unfailingly helpful at every stage of the process of preparing this book. John C. van Roden III, class of 2004, helped us select photographs and identify the individuals and groups depicted.

We are also grateful to Lancaster Newspapers Inc. for permission to publish several photographs from its collection.

Franklin & Marshall's Committee on Grants awarded a Hackman Scholarship to enable Jane Bee to work on this project during the summer of 2004. Provost Bruce Pipes and Associate Deans D. Alfred Owens and Ann Steiner have been supportive throughout.

We are grateful to Richard Kneedler, David Stameshkin, and Sally Griffith, who read earlier versions of this book. Nancy Siegel first suggested that we undertake this project, and she too critiqued an earlier version of our text and advised us on the layout of the pages.

Just as the central figure in the Wonsetler mural in the Shadek-Fackenthal Library looks back on the past and forward to the future, colleges are both keepers of history and shapers of what will be. Pres. John Fry, though only on campus for two years, embraces both of these responsibilities. He has been an enthusiastic supporter of this project from the beginning.

INTRODUCTION

Franklin & Marshall College is the 13th oldest institution of higher education in the United States. Benjamin Rush, who was largely responsible for its creation, anticipated that the college would promote the assimilation of the Germanic population into the mainstream and make them contributing citizens of the new republic. The college's founders included four signers of the Declaration of Independence, three future governors of Pennsylvania, and four members of the Constitutional Convention. They named the new institution after Benjamin Franklin, its first benefactor, who had donated £200. In the petition to the legislature requesting a charter of incorporation and the gift of public land to support the college's mission, the founders proposed to teach students a classical curriculum as well as "such other branches of literature as will tend to make good men and useful citizens." True to Franklin's intent, the development of civic culture has been at the center of the college's mission since its founding.

Marshall College was incorporated in 1836 and named in honor of Chief Justice John Marshall, who had died the previous year. Frederick A. Rauch, the first president, was a distinguished scholar and the first interpreter of Hegelian philosophy in the United States. Under his leadership, Marshall College attracted an outstanding faculty that included Theodore Appel, John Williamson Nevin, William M. Nevin, Thomas C. Porter, and Philip Schaff. The college's faculty, its curriculum, and its commitment to educating the whole individual all made it a distinctive place.

In 1853, Franklin College merged with Marshall College. The preamble to the legislative act of incorporation predicted that the new college would confer "a more extensive benefit . . . upon the citizens of this State in the promotion of liberal & scientific learning." James Buchanan, president of the board of trustees of the newly merged college and later the 15th president of the United States, chose a 10-acre site for the campus. This hilltop, at the western edge of the city a mile from the center of Lancaster, became known as College Hill. The college was thus located within the city but removed from the noise and congestion of urban life. To meet the educational needs of the new institution, the trustees erected a large Gothic Revival building, the College Building, and aided students in erecting two flanking literary society buildings, Goethean and Diagnothian Halls. The use of the Gothic Revival style for the original buildings was an important statement of the college's religious origins and also of its educational mission, an assertion that Franklin & Marshall College was heir to a tradition of scholasticism extending back to the founding of the great European universities in the Middle Ages.

Over the last 150 years, the campus on College Hill has evolved from these beginnings to include more than 50 buildings that provide classroom, laboratory, library, cultural, and residential space for almost 2,000 students. The historic core of the campus—14

buildings and 3 landscape features—has been entered in the National Register of Historic Places.

Just as the campus has grown and changed, so have other aspects of college life evolved. Residentiality was one crucial development: until World War II, most students boarded in homes throughout Lancaster. Students who lived on campus became involved in a host of activities ranging from intercollegiate athletics to debate clubs, the Green Room Theater, and a number of musical organizations. Equally important was the college's decision to become coeducational. Pres. Keith Spalding, who favored that choice, patiently led the institution through a series of discussions that resulted in the decision to change, in fundamental ways, a historic college. A third change was the internationalizing of the student body, which brought different cultural traditions and a global perspective to the campus.

Franklin & Marshall entered the new millennium as a national liberal arts college. With a faculty of 160 and a student-faculty ratio of 11 to 1, it emerged from the crisis years of the early 1970s a thriving college committed to the centrality of the liberal arts in a rapidly changing world.

The following pages present more than 200 images that illustrate important events in Franklin & Marshall's rich history. While the choice of photographs is subjective, we have tried to be as inclusive as possible. We hope that this photographic history will be interesting to all alumni and friends of the college.

One

BEGINNINGS
1787–1852

Franklin & Marshall College began as two separate institutions. Franklin College was established in Lancaster, Pennsylvania, in 1787 and named for benefactor Benjamin Franklin. Embodying the ideals of many members of the Revolutionary generation, Franklin College attempted to educate the Germanic population of the state in republican values and civic culture as well as classical learning. The college was supported by the Lancaster community and by the German Reformed and Lutheran Churches. Although Franklin College had its beginnings as a Protestant institution, a Catholic priest served as a member of the first board of trustees and Jewish students were enrolled in the first class.

Marshall College began as a classical institute affiliated with the German Reformed Seminary in York, Pennsylvania. A year after the school moved to Mercersburg in 1835, it became a college and was named in honor of the eminent jurist John Marshall. Marshall College attracted a distinguished faculty headed by Pres. Frederick A. Rauch, a German-born and German-educated scholar who was the first interpreter of Hegelian philosophy in the United States. Other important faculty included John Williamson Nevin and Philip Schaff, who built upon Rauch's philosophical ideas and developed what historians of religion term the Mercersburg Theology. Marshall College's faculty and educational philosophy launched Franklin & Marshall as a distinctive institution.

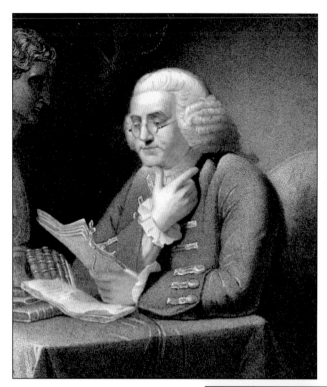

Benjamin Franklin (1706–1790), printer, inventor, scientist, and statesman, was Philadelphia's greatest promoter of civic culture. He played essential roles in the establishment of the Library Company of Philadelphia, the American Philosophical Society, the University of Pennsylvania, and Pennsylvania Hospital and negotiated the Treaty of Paris, which secured American independence. Franklin was the largest contributor to the new college in Lancaster, and acceded to Benjamin Rush's request that it be named in his honor.

John Marshall (1755–1835) was appointed fourth chief justice of the U.S. Supreme Court in 1801. In a series of important decisions, Marshall defended the independence of the judiciary and established the court as the ultimate arbiter of the Constitution. The German Reformed Synod, which established a new college in Mercersburg in 1836, named the college after Marshall to honor his "exalted character, great worth, and high mental attainments."

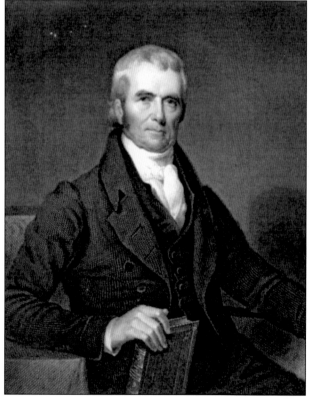

The following Gentlemen have paid their Subscription towards Franklin College in Lancaster

His Excellency Benj.ⁿ Franklin Esq.ʳ Cash paper £200 —

Robert Morris Esq.ʳ being old Continental Loan Office Certificates in favour of John McMickin, who not being a Resident in this State cannot be changed by the Comptroller — The amo.ᵗ 600 D.ʳˢ which have drawn Int.ᵗ on France for some Years —

Hon: Peter Muhlenberg Esq.ʳ in Certif.ᵗ £50		
Charles Biddle Esq.ʳ	D⁰	18.17
Wm. Rawle Esq.ʳ	D⁰	37.10
George Fox Esq.ʳ	D⁰	37.11.11½
Frederick Kuhl	D⁰	50.5.3
Rob.ᵗ Traile Esq.ʳ	Paper Money	3
Samuel Dean Esq.ʳ	Ditto	3
John Smilie Esq.ʳ	Ditto	3
John Beard Esq.ʳ	Ditto	3
David Reddick Esq.ʳ	Ditto	3
John Arndt Esq.ʳ	Ditto	4.10
Henry Hill Esq.ʳ	a Certificate	37.10
Interest receiv'd on some of the Certificates		6.19.3
		£226.9.3
Paid at several Times ⅌ Order		91.—.11
Remains in my Hands a Ballance of		£135.8.4

Frederick Kuhl

This list records the individuals who paid their subscriptions for the establishment of Franklin College. The first name listed is "His Excellency" Benjamin Franklin (then president of the Supreme Executive Council of Pennsylvania), who contributed £200. Franklin's name is followed by Revolutionary War financier Robert Morris and Peter Muhlenberg, a Revolutionary War general and Lutheran minister who was then vice president of the Supreme Executive Council and the brother of Henry Muhlenberg.

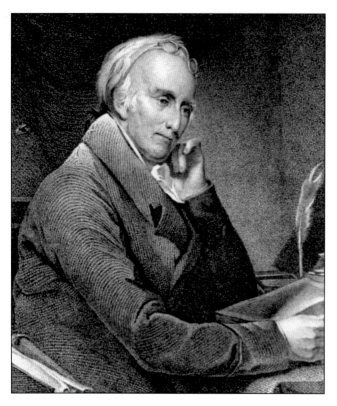

Benjamin Rush (1746–1813), physician, educator, patriot, and civic leader, was the foremost early American physician. Rush was the most important individual in the establishment of Franklin College. At the first meeting of the trustees, Rush expressed his hope that the college would be the means by which the "partition wall which has long separated the English and German inhabitants of the State will be broken down."

Ordnung

welche in Absicht der

Proceßion und öffentlichen Gottesdienstes

bey der

Einweihung

der

Franklinischen Deutschen Hohe Schule,

in der Stadt und Grafschaft

Lancaster,

zu beobachten.

Philadelphia:

Gedruckt bey Melchior Steiner, in der Rees-straße, zwischen der Zweyten- und Dritten-straße. 1787.

ORDER

OF

PROCESSION and PUBLIC WORSHIP

to be observed in the

DEDICATION

OF

FRANKLIN COLLEGE,

in the Borough and County of

LANCASTER.

PHILADELPHIA:

Printed by MELCHIOR STEINER, in Race-street, between Second- and Third-streets. 1787.

Order of Procession and Public Worship to be observed in the Dedication of Franklin College was printed in both English and German. Participants in the dedication processed from the Lancaster County Court House in Center Square to the Evangelical Lutheran Church of the Holy Trinity, two blocks away on South Duke Street. The dedication took place on June 6, 1787.

Henry Muhlenberg (1753–1815), born Gotthilf Heinrich Ernst Muhlenberg, was the first principal of Franklin College. The son of Henry Melchior Muhlenberg, patriarch of the Lutheran Church in the United States, he was minister of the Evangelical Lutheran Church of the Holy Trinity in Lancaster and was a noted botanist. Muhlenberg's herbarium is at the Academy of Natural Sciences in Philadelphia.

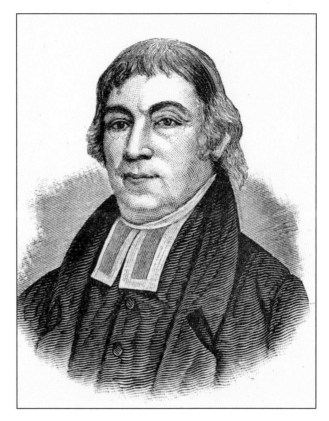

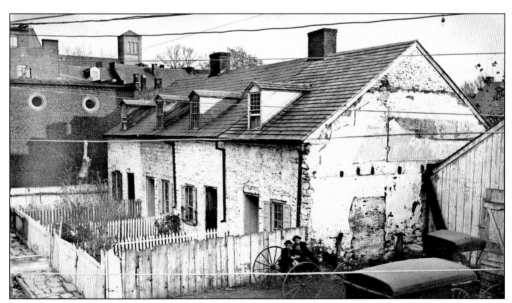

The first building of Franklin College, known as the Brew House, was located on Mifflin Street. Instruction began on July 18, 1787, and continued into the following year.

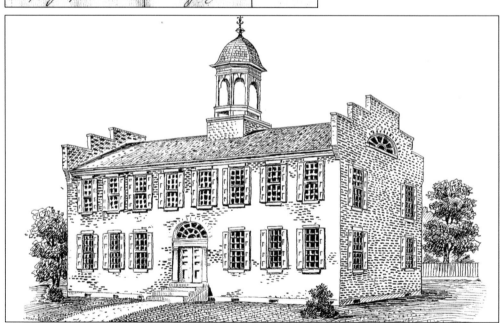

This page lists some of the students who attended the English school of Franklin College. The class for 1788 included a number of female students, including, on this page, Elizabeth Grubb, Richea Gratz, and Margaret Coleman. Richea Gratz may have been the first female Jewish college student in the United States.

The third building of Franklin College, erected in 1827 as the Lancaster County Academy, was located at the corner of Orange and Lime Streets. The college acquired the former academy building in 1840. It served Franklin College and then Franklin & Marshall College until completion of the College Building (Old Main) in 1856.

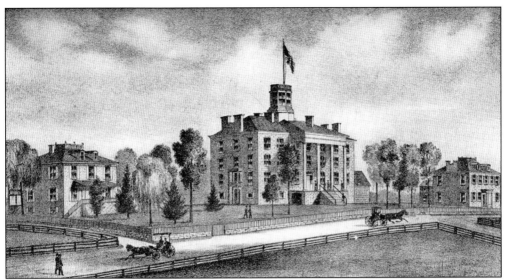

Founded as a classical school in York, Pennsylvania, Marshall College relocated to Mercersburg in 1835 and became a college the following year. The four-story Main Hall (center) was erected in 1836–1837 to house both the Theological Seminary of the German Reformed Church and Marshall College. It contained dormitory rooms for students as well as classrooms. The flanking cottages were erected as residences for professors.

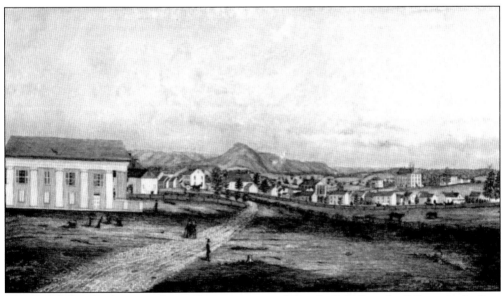

This 1846 sketch of Mercersburg illustrates several Marshall College buildings, including the four-story Main Hall, near the right in the middle distance. The Greek Revival building at the left is Diagnothian Hall, housing one of the two literary societies established at Marshall College. Designed by Prof. Samuel W. Budd and erected by students in 1845, the literary society building contained a library and cabinet of curiosities on the first floor and a large meeting room on the second.

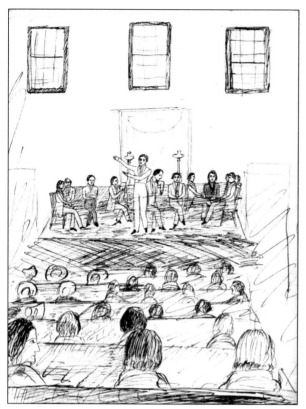

These vignettes are taken from a Marshall College student publication, *RUPJONJIM*, written during the winter term of 1840–1841. The title probably reflects the names of the authors and editors. The sketch to the left depicts a student delivering an oration in one of the literary society buildings. The sketch below reveals a classroom recitation; given the books on the shelf, the class is probably English literature. These vignettes capture the two principal arenas for student intellectual life at Marshall College: the student-organized literary societies and formal learning in the classroom.

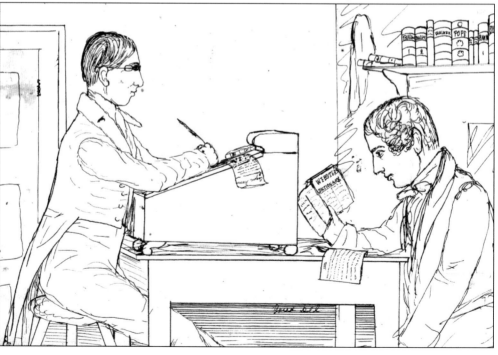

This *RUPJONJIM* sketch of the U.S. Capitol depicts the inauguration of Pres. William Henry Harrison. The ninth president stands with his hand on a Bible while taking the oath of office. The accompanying text described March 4, 1841, as "a great day to the greater part of the inhabitants of the United States."

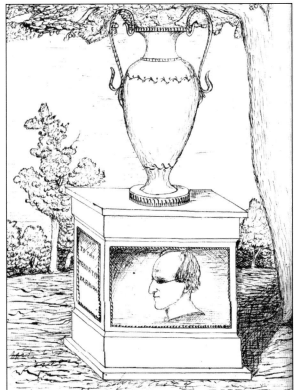

"To the Memory of Rauch." Frederick A. Rauch (1806–1841) immigrated to the United States in 1831 and was named professor of theology at the German Reformed Seminary in York. The first president of Marshall College, Rauch was author of *Psychology* (1841) and a principal figure in the emergence of the Mercersburg Theology. The unexpected death of this beloved teacher and scholar at age 34 was a severe blow to students and colleagues.

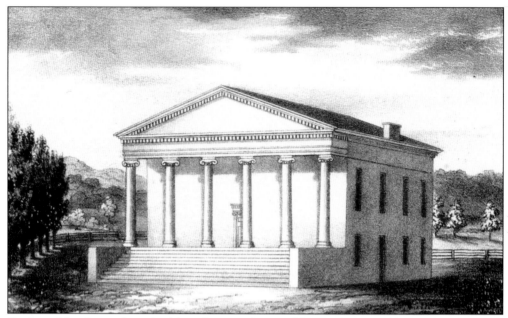

Designed by Samuel W. Budd and erected in 1844, Goethean Hall was home to one of the two literary societies that were an important part of the students' education. The Goethean and Diagnothian Societies moved to Lancaster with the merger of Franklin College and Marshall College.

The seal of Franklin College presents an image of Minerva dispensing knowledge to a young man. The Latin motto is "Knowledge leads me crowned with laurel to the stars." The Marshall College seal presents an image of John Marshall with the motto "Law and Light." The Franklin & Marshall College motto reversed the order of the words to become "Lux et Lex."

18

Two

COLLEGE HILL TAKES SHAPE
1853–1889

Trustees, faculty, students, and citizens dedicated Franklin & Marshall College on June 7, 1853. Pres. Emanuel V. Gerhart began raising money for a campus that would meet their expectations for the new institution. Faculty held classes in the Lime Street building until construction of the College Building (Old Main), which was dedicated on May 16, 1856. The two literary society buildings, Goethean and Diagnothian Halls, were completed in July 1857. Prof. Thomas C. Porter led students in purchasing and planting trees to embellish the new campus.

The years from 1853 to 1889 constitute a distinct era in Franklin & Marshall's history. Gerhart and Pres. John Williamson Nevin gave the college a unique identity rooted in German idealism and the Mercersburg Theology. The curriculum, like that of most colleges, included classical languages and mental and moral philosophy, but also courses on German language and literature. The exhumation and reburial in the Lancaster Cemetery of Frederick A. Rauch in 1859, and the erection of a monument to Rauch on the new campus, testified to the continuing influence of his ideas. Nevin was also deeply revered by students and alumni, who called the college "Nevonia" in his honor for more than 50 years. This tradition has been revived through the establishment of the Nevonian Society to recognize 50-year alumni of the college and the 2002 naming of the new president's house Nevonia.

Most students boarded in houses some distance from the campus, which was a mile from the center of Lancaster. In the early years, the literary societies were centers of student social life. As the college matured, students organized baseball and football teams, an orchestra and a glee club, and dining clubs. During these years, the college survived difficult financial challenges and marked the centennial of the founding of Franklin College and the 50th anniversary of the founding of the two literary societies.

James Buchanan (1791–1868), a prominent Lancaster attorney and politician, was the 15th president of the United States. Buchanan was a member of the board of trustees of Franklin College from 1837 to 1853 and president of the board of trustees of Franklin & Marshall College from 1853 to 1865. He led the community effort to merge the two colleges and presided at the dedication ceremonies held at Fulton Hall on June 7, 1853.

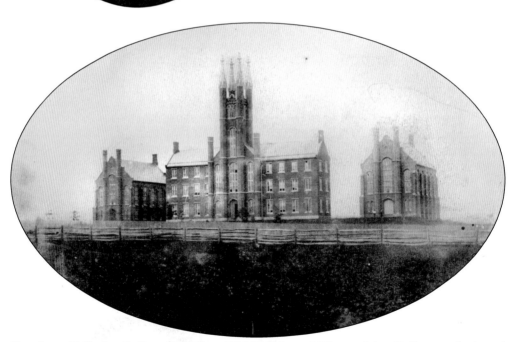

Goethean Hall, the College Building (Old Main), and Diagnothian Hall were designed by Baltimore architects Dixon, Balbirnie & Dixon. The cornerstone of the College Building was laid on July 24, 1854, and the building was dedicated on May 16, 1856. The cornerstones of the literary society buildings were laid on July 20, 1856, and the buildings were dedicated a year later. This photograph was taken in 1859.

Prior to the formal opening of Franklin & Marshall College, trustees, faculty, and students processed from the third Franklin College building on Lime Street to Fulton Hall. There they were met by the clergy of the city, the mayor, and other elected officials. Judge Alexander L. Hayes gave an address of welcome on behalf of the city, John W. Nevin presented remarks on behalf of the faculty, and Bishop Alonzo Potter spoke for the board of trustees.

FORMAL OPENING

OF

FRANKLIN AND MARSHALL COLLEGE,

IN THE

CITY OF LANCASTER,

June 7, 1853:

TOGETHER WITH

ADDRESSES

DELIVERED ON THE OCCASION,

BY HON. A. L. HAYES, REV. J. W. NEVIN, D. D., AND RIGHT REV. ALONZO POTTER, D. D.

LANCASTER, PA:
PUBLISHED BY ORDER OF THE BOARD OF TRUSTEES.

1853

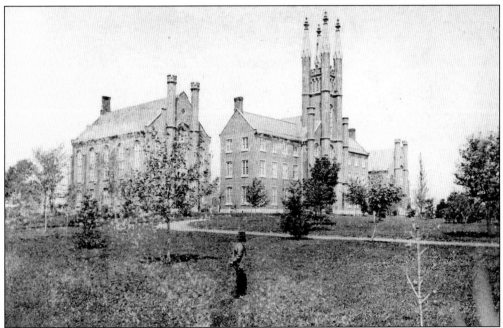

The trees in front of Goethean Hall, the College Building (Old Main), and Diagnothian Hall were planted in 1857 by students under the direction of Thomas Conrad Porter, a member of the Franklin & Marshall faculty who, in later years, wrote a series of important botanical studies, including *Flora of Pennsylvania.*

Emanuel Vogel Gerhart (1817–1904), a distinguished theologian and scholar, was the first president of Franklin & Marshall College. An 1838 graduate of Marshall College, he served as president of Franklin & Marshall from 1855 until 1866, and for the following two years he taught mental and moral philosophy. In 1868, Gerhart became president of the Theological Seminary in Mercersburg and was instrumental in moving it to Lancaster in 1871.

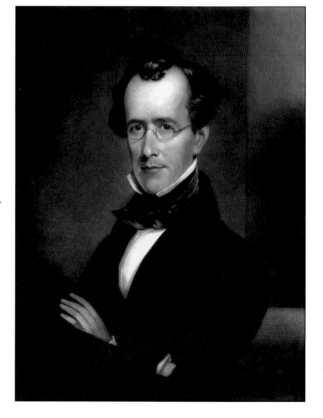

John Williamson Nevin (1803–1886), theologian and educator, served as the second president of Franklin & Marshall, from 1866 to 1876. He had been president of Marshall College from 1841 to 1852. Nevin was a principal figure in the development of the Mercersburg Theology, which rejected revivalism and embraced Christology, the centrality of Christ's life and crucifixion as tenets of faith. Nevin was a beloved leader who was eulogized as the "presiding spirit" of the college.

This stained-glass window, placed behind the altar in the College Chapel (Nevin Chapel), depicts Christ with a chalice in his right hand. Near the bottom are the following words: "To the glory of God amen and in loving memory of John Williamson Nevin, DD LLD. June 6th AD 1886." (Photograph by Marcy Dubroff, 2004.)

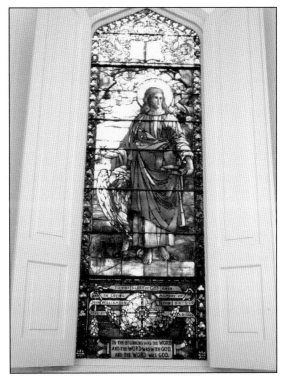

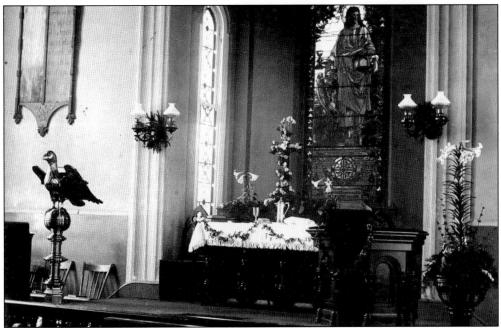

The chapel, decorated for Easter in 1892, exemplifies the Mercersburg Theology, which introduced to the Reformed Church the ritual that had been stripped away from Protestant churches during the Reformation. It marked a turning away from the austere building tradition of the Reformation and embraced the use of Gothic forms, stained glass, and architectural sculpture to create sanctuaries in keeping with the new liturgy.

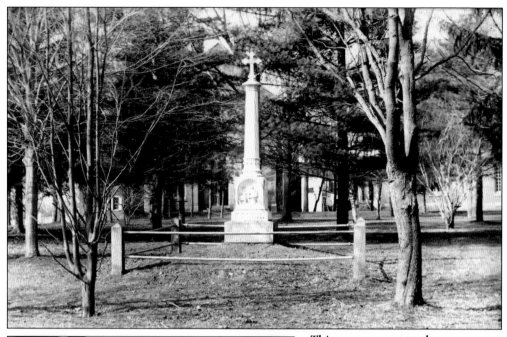

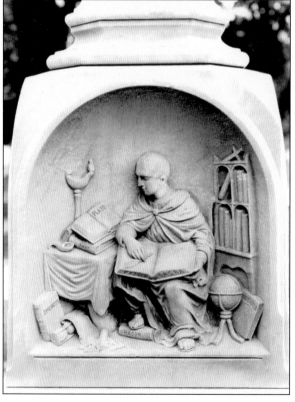

This monument to the memory of Frederick A. Rauch, sculpted by Davoust Kern and unveiled at commencement in 1871, stood in front of Goethean Hall. The relief sculpture (left) portrays Rauch as a medieval scholar in his study, surrounded by a globe, a Gothic bookcase, and the lamp of learning. He is comparing the text of *Sacred Scripture* with a book by Plato on the table. The monument was moved to Rauch's grave in the Lancaster Cemetery in 1892.

Thomas Conrad Porter (right) taught natural science from 1852 to 1866. Theodore Appel (below, left) held various posts at the college. He was professor of mathematics and mechanical philosophy from 1852 to 1866; professor of mathematics, physics, and astronomy from 1866 to 1872; and professor of physics and astronomy from 1872 to 1877. William Marvell Nevin (below, right) was professor of ancient languages and belles-lettres from 1852 to 1872 and alumni professor of English literature and belles-lettres from 1872 to 1887.

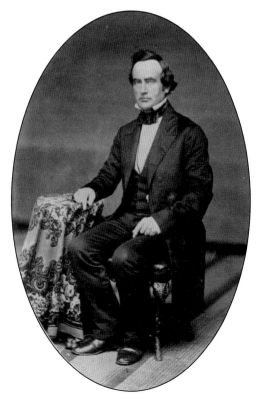

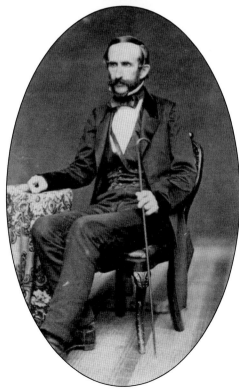

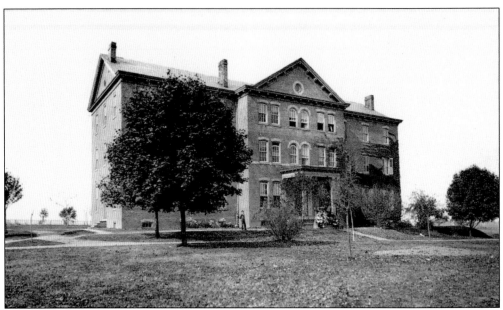

East Hall, designed by Philadelphia architect Samuel Sloan, was erected in 1872 to house Franklin & Marshall Academy, a preparatory school. It served as married student housing after World War II, and then as the college's central administration building until it was demolished in 1977.

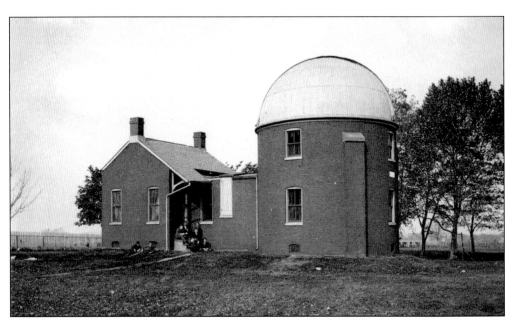

Designed by mathematics and astronomy professor Jefferson E. Kershner, Daniel Scholl Observatory was a gift to the college from Margaret Scholl Hood in 1884. It was named in honor of her father. The observatory was moved north to make way for new buildings in the 1920s and demolished in 1966, at the time of the construction of Grundy Observatory on Baker Campus.

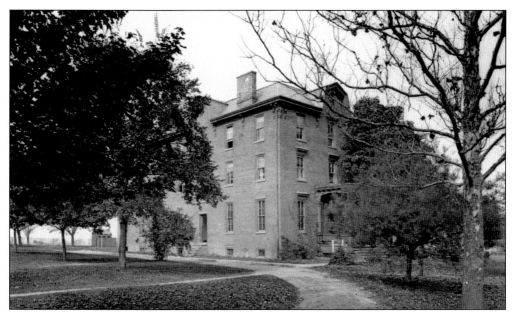

Harbaugh Hall, the college's first dormitory, was designed by Samuel Sloan and erected from 1871 to 1872. It contained rooms for 40 students and a large refectory. The dormitory was named in honor of Henry Harbaugh, a revered Reformed Church minister and college trustee who, in 1854, had urged the synod to erect housing for students. The building never functioned well and was demolished to make way for the Science Building (Stager Hall) in 1900.

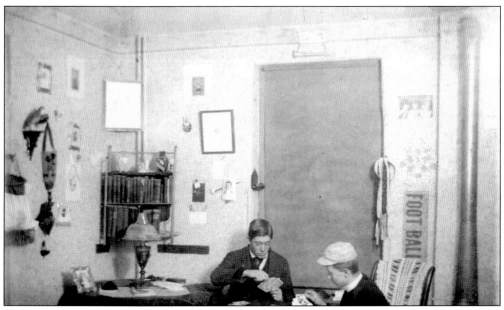

A. Leroy McCardell (left) and J. Clark Kieffer, members of the class of 1893, are shown playing cards in a Harbaugh Hall dormitory room.

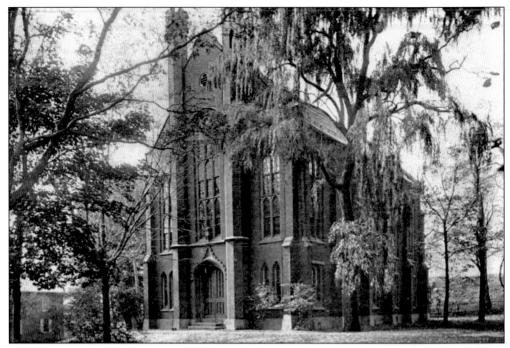

Literary societies were centers of student intellectual and social life at the college. Students raised much of the cost to erect their society buildings, each of which contained a library and cabinet of curiosities on the first floor and a meeting hall on the second. Seen above is Goethean Hall.

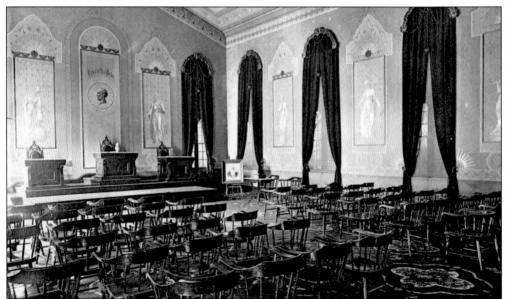

This 1892 photograph shows the second story of Goethean Hall. Henry Kyd Douglas, class of 1858, captured in his diary the pride students took in their societies. On December 19, 1857, he wrote, "There is no part of the week which I look forward with such interest and pleasure as Saturday morning, when our chosen Diagnothian band assemble in our own beautiful Hall to cultivate the garden of Literature."

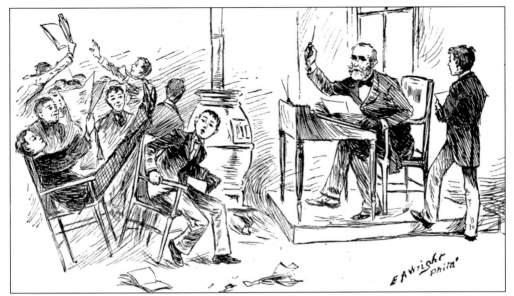

This depiction of classroom life was published in the 1888 *Oriflamme,* the Franklin & Marshall yearbook. The drawing, by E. A. Wright, accompanied an unsigned poem that expressed the wish that the author's classmates were "free from the snares of temptation, / And pleasures in deeds uncouth!"

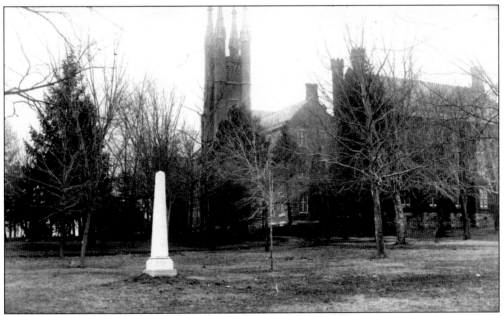

Erected by the senior class on June 26, 1872, this monument to Cyropaedia was inspired by Xenophon's biography of the Persian Cyrus the Great. The following year, students with "malignant motives" overturned the obelisk. Shortly after the editors of the *College Student* succeeded in re-erecting the monument, it was again overturned and was subsequently taken by students to the cellar of Harbaugh Hall. Its location today is unknown.

Glossary.

COLLEGE.—An institution which gives the Faculty an opportunity to display their powers.

FACULTY.—A company of learned men who were boys once, but who have forgotten it.

RECITATION.—A set-to between the Professor and Student, without gloves, three minute rounds, Marquis of Queensbury rules. Professor generally succeeds in knocking the Student out in the first round.

EXAMINATION.—An enlarged edition of recitation. The contestants fight to a finish.

STUDENT.—A nice young man, sent to college to "learn eddication, aint?" No bad habits. The best ones are known as "hard students," because they study so unceasingly, and the worst ones are known as "hard students," because they *don't* study so unceasingly.

SENIOR.—The man who wears a plug hat. There is an idea current among the uninitiated that Seniors wear plugs because they have such huge brains. This, however, is false. They cannot justly be accused of owning anything like brains.

JUNIOR.—The man who does'nt think he knows quite as much as he did last year. Though he knows less, he has more sense. He is quite harmless if left to himself.

SOPH.—The man who paralyzes the Professors with his brainy questions. Often taken for a Prep.

FRESHMAN.—The man who swears off in September instead of January. He's the man of good resolves. The nation's eye is upon him, and he feels it. He has never been pulled.

CUT.—Means that the circus is in town.

CLASS.—That which cuts.

CHOIR.—A number of students who exhibit their wisdom teeth every morning.

CHAPEL ORGAN.—A musical instrument, worked by a pump handle. Its Siren tones resemble the filing of a saw. And yet the Student sleepeth. The upright man sleepeth soundly.

GLEE CLUB.—A band of troubadors, which took a trip last winter, and now is living in affluence from the proceeds of its concerts. Please don't compliment

This humorous glossary of college life was published in the 1887 *Oriflamme.*

In this sketch from the 1883 *Oriflamme,* members of the college Glee Club sing "Oft in the Stilly Night," a popular song arranged by John Stevenson, who used verse by the Irish poet Thomas Moore as the lyrics.

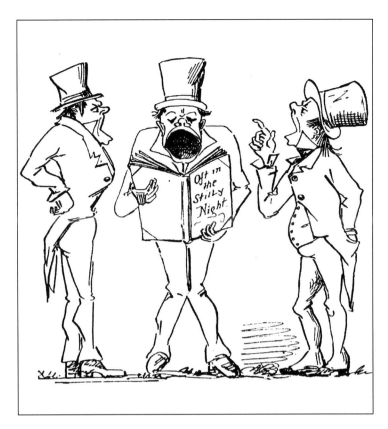

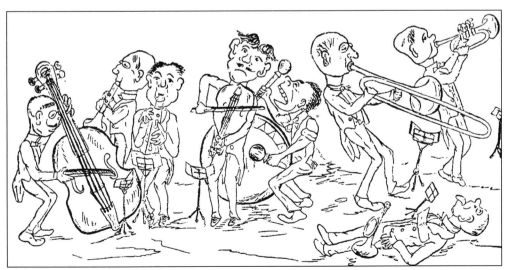

This sketch of the college orchestra appeared in the 1884 *Oriflamme.*

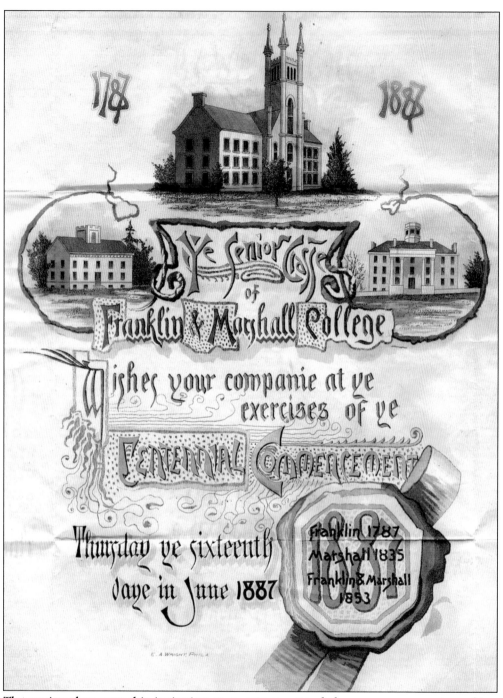

The senior class sent this invitation to guests to attend the commencement marking the centennial of the founding of Franklin College in 1887. The buildings represent the three phases of the college's institutional history: the Store House (left), the second home of Franklin College; the seminary (right) in Mercersburg that was home to Marshall College; and the College Building (center), the original structure on the Franklin & Marshall campus.

The inaugural event in the centennial celebration was the baccalaureate sermon, preached by Thomas G. Apple on Sunday, June 12, 1887. On June 14, a large meeting featured speeches on the lives of Benjamin Franklin and John Marshall. The following day, there was a celebratory luncheon on campus and more speeches at the Lancaster County Court House in the evening. Commencement and the centennial reception took place on Thursday.

Thomas Gilmore Apple (1829–1898) was the third president of the college. An 1850 graduate of Marshall College, he became a professor at the Theological Seminary in Mercersburg in 1871 and moved to Lancaster along with the seminary. Following the resignation of John Nevin, Apple was named interim president in 1877 while continuing to teach at the seminary. He served as president until 1889 and maintained the philosophical traditions of the Mercersburg Theology.

33

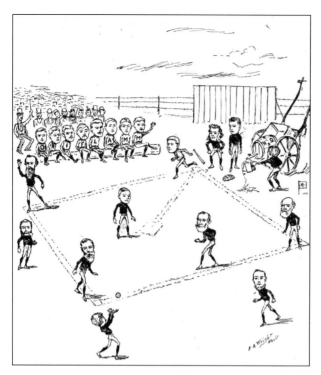

In this 1888 sketch, faculty and *Oriflamme* staff compete in a baseball game. The team in the field consists of Pres. T. G. Apple (catcher); Prof. G. F. Mull (pitcher); Prof. J. S. Stahr, Prof. J. B. Kieffer, Prof. W. Nevin, and Prof. E. V. Gerhart (infielders); and Prof. J. Dubbs, Prof. J. Kershner, and Prof. F. A. Gast (outfielders). Gerhart and Gast were affiliated with the Theological Seminary of the Reformed Synod, which shared space with the college.

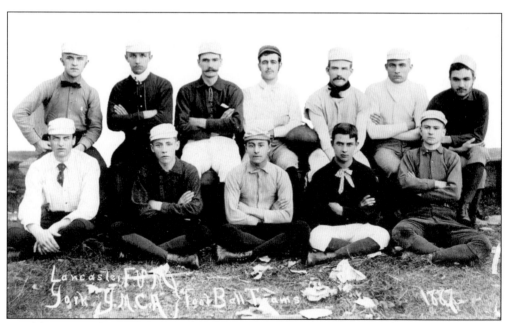

Franklin & Marshall's first football team organized in the fall of 1887. Pictured here are W. P. Sachs, A. Conner, J. T. Ankeney, J. S. Hartman, captain J. C. Noll, F. M. Line, R. N. Koplin, W. H. Kellar, F. A. Rupley Jr., H. H. Apple, C. E. Hilliard, and C. E. Heller. The team played two games against the York YMCA and lost both by scores of 9-0 and 6-4.

Three

TOWARD A MODERN COLLEGE
1889–1909

The presidency of John Summers Stahr was a time of growth, both in the number of students and the facilities available to them, and a time of curricular innovation. Enrollment soared from 115 students in 1889 to 214 in 1909. During the two decades of Stahr's presidency, the college erected its first library (Watts DePeyster), a gymnasium (the modern Distler House), the Science Building (the modern Stager Hall), and an athletic field with grandstand (the modern Sponaugle-Williamson Field), as well as a new building for Franklin & Marshall Academy (Hartman Hall).

The most significant curricular innovation was the modernization of teaching and facilities in the natural sciences. Stahr had long argued the importance of education in biology and chemistry, and as president, he pushed for an addition to the College Building to provide space for two laboratories. He made a new science building a high priority, as well as the addition of new faculty positions in the sciences. Stahr enlarged the curriculum while maintaining its distinctive grounding in the Mercersburg Theology.

These years also saw the development of an array of student activities, including intercollegiate athletics, the Green Room Theater Club, musical organizations, literary and journalistic publications, and the establishment of several new fraternities. The Goethean and Diagnothian Societies remained centers of student intellectual and social life. Although the demolition of Harbaugh Hall in 1900 left the college without student dormitories, dining clubs emerged to provide additional opportunities for socializing.

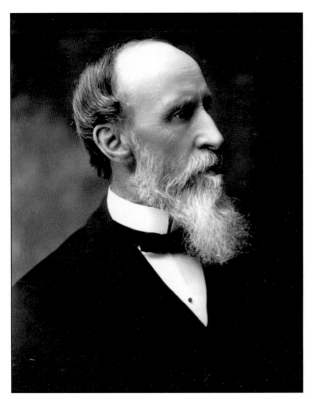

John Summers Stahr (1841–1915) served as the fourth president of the college. After graduating from Franklin & Marshall in 1867, he joined the faculty as tutor of history and German. In 1871, Stahr became professor of natural science and chemistry. Named president in 1889, he then taught mental and moral science, aesthetics, and the philosophy of history. Stahr grafted laboratory science to the classical curriculum and presided over an ambitious building program.

Joseph Henry Dubbs (1838–1910), an 1856 graduate of Franklin & Marshall, was pastor of Christ Reformed Church in Philadelphia. When Lewis Audenried left a $35,000 bequest to establish a chair in history and archaeology, his will specified that Dubbs be the first holder of that position. Appointed Audenried Professor in 1875, Dubbs wrote the first history of Franklin & Marshall as well as important histories of the Reformed Church.

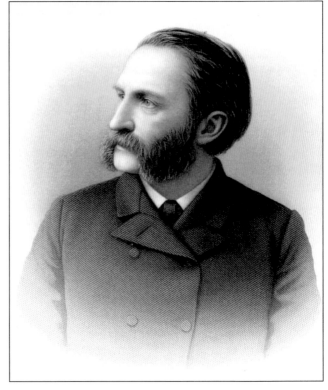

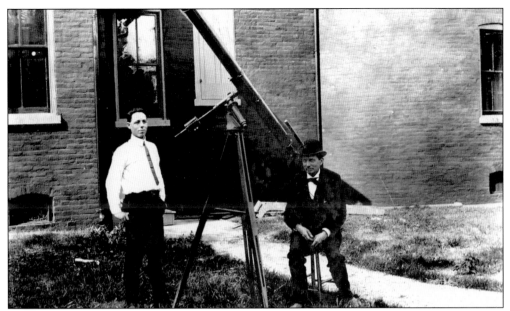

Jefferson E. Kershner, seated outside Daniel Scholl Observatory with an unidentified student, was an 1877 graduate of the college. He completed the Ph.D. at Yale and was the first member of the Franklin & Marshall faculty with an earned doctorate. Kershner won a national reputation for his research in electricity. A plaque erected by the class of 1906 described him as "outspoken, frank and brusque in manner, but with a mind, character, and personality of the utmost integrity."

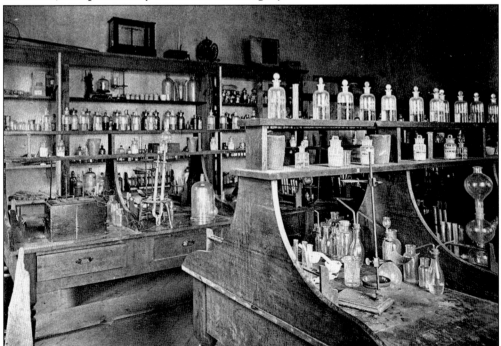

This laboratory was one of two accommodated in the 1890 one-story addition to the northwest corner of the College Building.

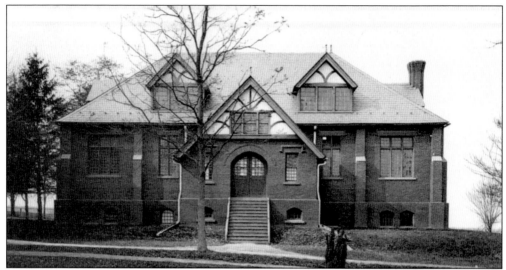

Recognizing the "necessity of physical exercise . . . to the highest order of intellectual labor," the college erected its first gymnasium in 1891. It contained a running track, gymnastic equipment, and a bowling alley. Following construction of Biesecker Gymnasium, this building became the Campus House in 1927. Renovated for administrative offices in 1976, it was named Distler House in honor of Pres. Theodore Distler. This photograph was taken in 1892.

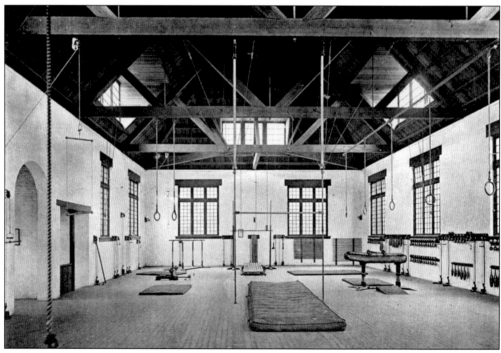

This 1892 shows the new gymnasium fitted for gymnastic exercises. The equipment was purchased using funds raised by students.

38

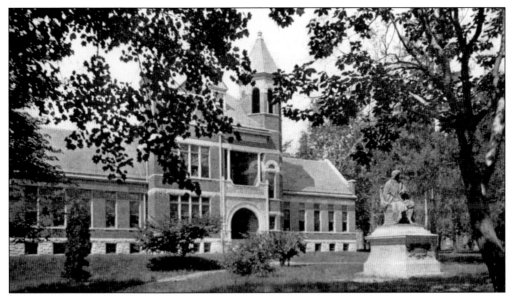

Watts DePeyster Library, a gift of John Watts DePeyster in honor of his grandfather John Watts and his father, Frederick DePeyster, was dedicated in 1898. Designed in a vaguely Romanesque Revival style by M. O'Connor, the library could accommodate 70,000 volumes, as well as reading areas for students and faculty. The statue of Abraham DePeyster, an 18th-century ancestor of the donor, stands at the head of West James Street. The building was demolished in 1937. This photograph was taken in 1906.

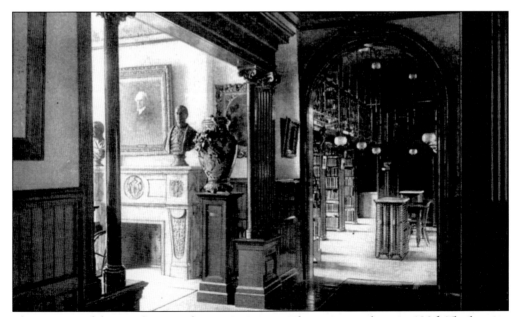

The interior of the south wing of Watts DePeyster Library is seen here in 1906. The bronze busts on the mantle in the Magazine Room, located to the left and right of a portrait of John W. Nevin, depict John Watts and John Watts DePeyster. They now stand in the lobby of Shadek-Fackenthal Library. The south stacks are in the room directly ahead.

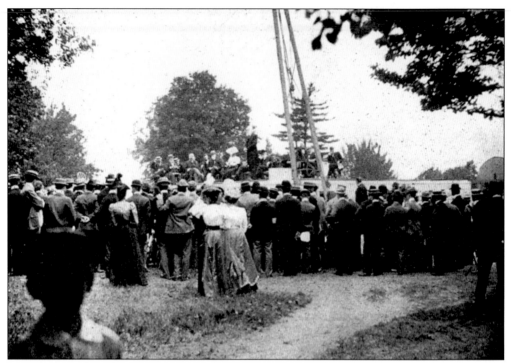

Pres. J. S. Stahr addresses the crowd during the cornerstone-laying ceremony for the Science Building on June 13, 1900.

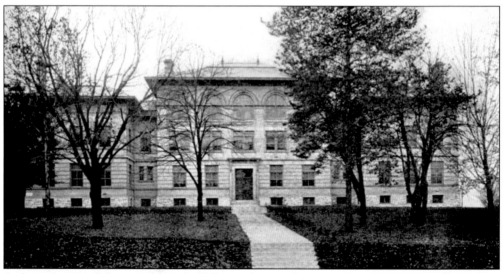

Stahr recognized that a modern building to house the natural sciences was "of supreme importance for the College and the community." Designed by Lancaster architect C. Emlen Urban and erected from 1900 to 1902, the Science Building housed laboratories, classrooms, and faculty offices. Named in honor of John S. Stahr in 1935, the building was renamed in honor of Henry P. Stager, class of 1932, in 1988. This photograph was taken in 1906.

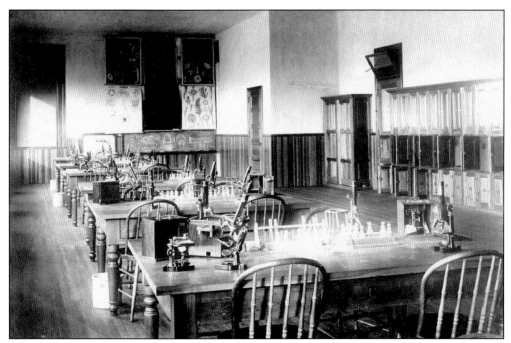

The new Science Building included a general biology laboratory (above), a lecture room (below), and other facilities.

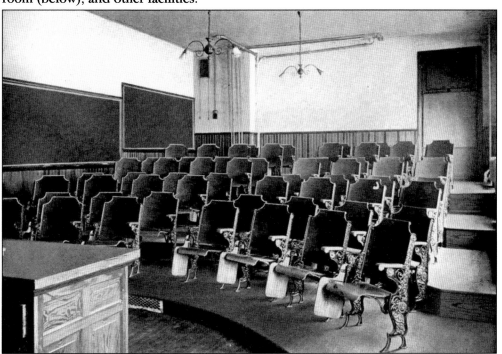

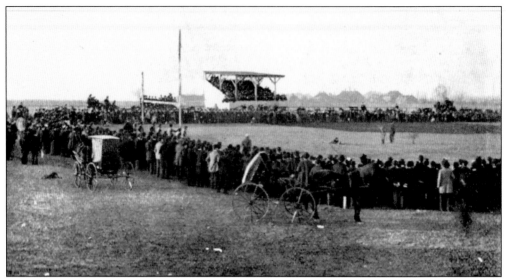

In 1894, H. S. Williamson supervised a group of students who solicited contributions from Lancaster businessmen to build a new athletic field. Construction took place in 1895 and 1896. When completed, the athletic field consisted of a combined football and baseball field surrounded by a quarter-mile track. The grandstand stood to the west of the field, while three tennis courts stood to the north.

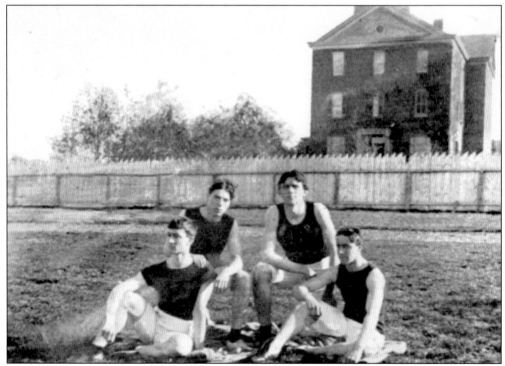

The Franklin & Marshall relay team is shown on the athletic field in 1897, with East Hall in the background. From left to right are the following: (first row) J. H. Bridenbaugh and H. S. Brugh; (second row) G. R. Reich and V. S. Beam.

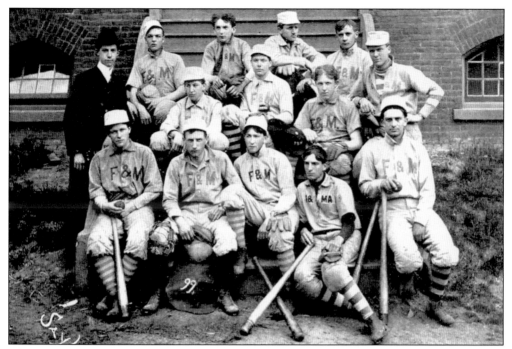

The 1901 baseball team, standing on the steps of the gymnasium, included the following, from left to right: (first row) Winters, Miller, Cook, Heisey, and Graybill; (second row) Helman, Peters, Simpson, and Stitzer; (third row) Evans, Shirk, Neely, Martin, and Treichler. Baseball became the first intercollegiate sport at the college in 1877.

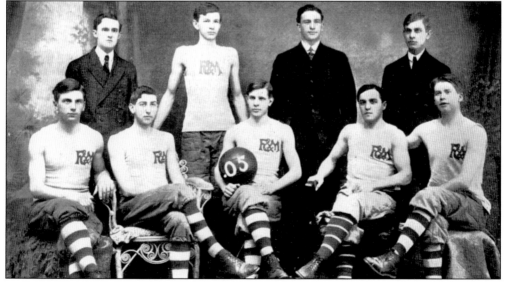

The 1905 basketball team members are A. H. Hull (forward and captain), J. A. Schaeffer (forward), W. L. Graul (center), A. Killheffer (guard), F. T. Ewing (guard), J. W. Appel Jr. (substitute), C. L. O. Graul (manager), and R. C. Gardner (assistant manager). The first intercollegiate basketball game took place against Millersville State Normal School in 1900.

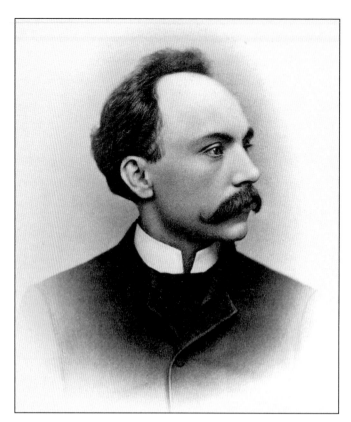

Richard C. Schiedt (1859–1951) joined the faculty in 1887 and taught German and modern languages. In the 1890s, he became professor of natural science. Schiedt, a native of Germany, supported his homeland during World War I. He resigned from the faculty in the face of controversy over his pro-German sentiments at a time of virulent anti-German hysteria. Schiedt was later named professor emeritus of biology in 1927.

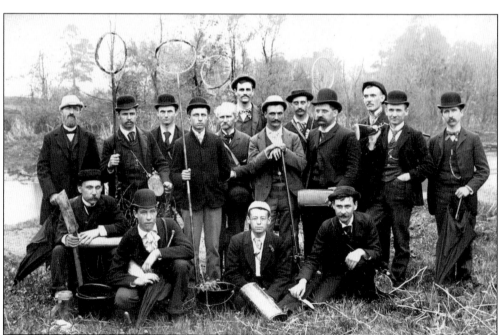

Members of the sophomore class accompanied the Lancaster Linnean Society on a botanical outing to Chickies Creek on May 19, 1892.

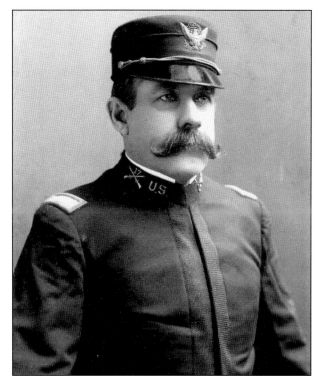

Edgar W. Howe (right), a graduate of the U.S. Military Academy and a lieutenant in the U.S. Army, served as professor of military science and tactics from 1894 to 1899. Student cadets, photographed in front of the Romanesque Revival entrance to the Lancaster Theological Seminary (below), trained twice weekly with Springfield rifles. Cadets wore the uniform of Howe's 17th Infantry.

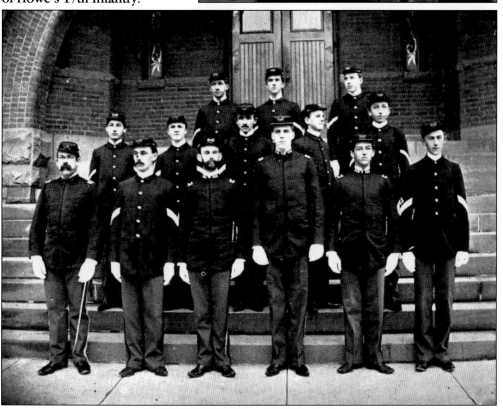

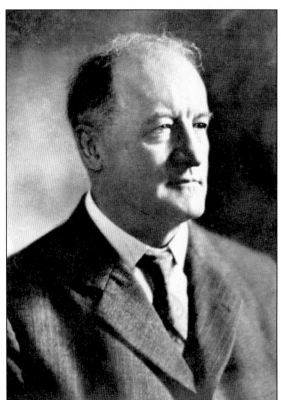

William M. Irvine, a Princeton graduate, had a significant impact on Franklin & Marshall while studying at the Lancaster Theological Seminary. As physical instructor and director of the college's gymnasium, he raised football to a major sport and also organized the student newspaper, *F&M Weekly,* and the glee club. Irvine taught English literature and political economy before becoming headmaster of Mercersburg Academy in 1893.

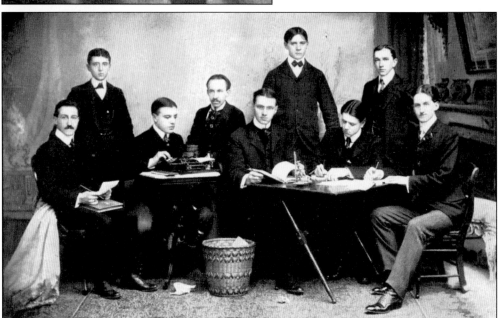

Five student publications existed in the early 20th century: the *College Student,* printed monthly by the literary societies; *F&M Weekly,* the campus newspaper; the *Nevonian,* the senior class's book; *Oriflamme*; and the student handbook, published by members of the campus YMCA. The *Oriflamme* staff is pictured in 1902.

This vignette drawn for the Green Room Club was included in the 1900 *Oriflamme* (right). Organized as the Dramatic Society in 1899 and renamed the Green Room Club the following year, this student theatrical society takes its name from the waiting room or lounge used by performers. *David Garrick,* the club's second performance, took place at the Fulton Opera House on February 16, 1900. The cast, including J. Robert Jones as Garrick, appears below.

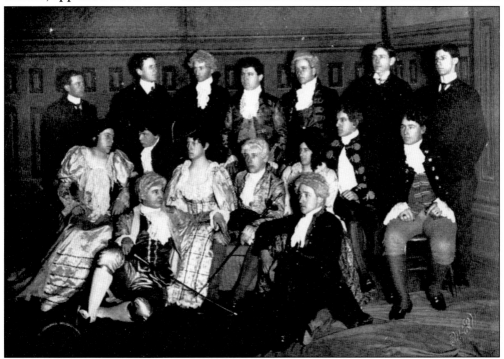

Because most students lived off campus, they had to find alternative ways of socializing. By the end of the 19th century, eating clubs had become important social organizations. Some dining clubs were named after important figures in the college's history (Nevonia, DePeyster, and Franklin, below); others bore the name of locations (the Harbaugh Hall Boys, the West End Eating Club); another, Ye Lotus Eaters (above, right), memorialized one of Tennyson's most famous poems. Most of the eating clubs evolved into fraternities.

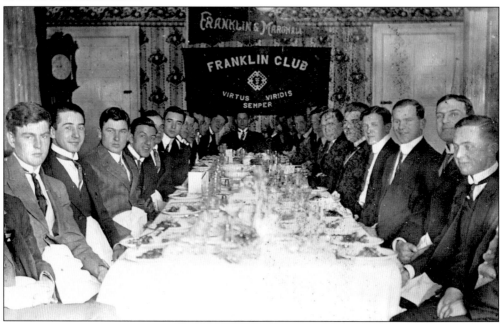

THIS TICKET ENTITLES

Mr. Frank R. Diffenderffer

To Seat No. 28 , Table C , at the "Golden Jubilee"

BANQUET

Of Franklin & Marshall College, Lancaster, Pa.

In the Woolworth Building, No. 21-29 North Queen St.

THURSDAY, JUNE 11, 1903, 7 P. M.

Present at the Elevator before 6:45 P. M. Guests will assemble in the Reception Room. Diagram will indicate location of your seat. Tables will be conspicuously lettered.

This ticket admitted guests to the Golden Jubilee banquet, which was held in the Roof Garden of the Woolworth Building, located on North Queen Street a half-block above Penn Square. Frank Diffenderffer noted on the reverse of his ticket, "I was there, and a most glorious time we had."

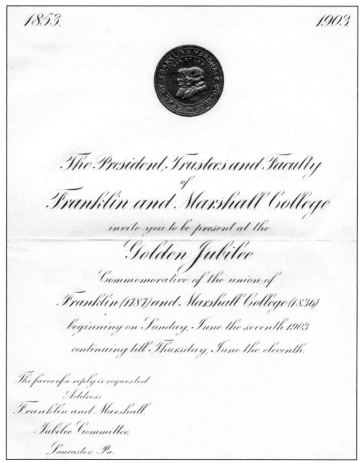

The Golden Jubilee celebrated the union of Franklin College and Marshall College to create the modern Franklin & Marshall.

1853. 1903.

The President, Trustees and Faculty

of

Franklin and Marshall College

invite you to be present at the

Golden Jubilee

Commemorative of the union of

Franklin (1787) and Marshall College (1836)

beginning on Sunday, June the seventh 1903

continuing till Thursday, June the eleventh.

The favor of a reply is requested

Address

Franklin and Marshall

Jubilee Committee

Lancaster, Pa.

49

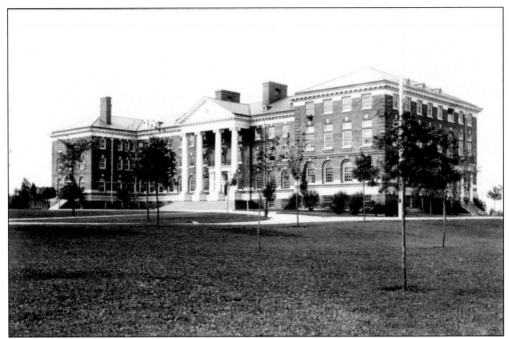

Designed by Philadelphia architects Newman and Harris, and made possible by a gift from Andrew Carnegie, Hartman Hall was dedicated in 1908 as the new building for Franklin & Marshall Academy. In 1946, the building was named Hartman Hall in honor of longtime headmaster Edwin M. Hartman. In succeeding years, the hall served as a dormitory and student center for the college. It was demolished in 1975.

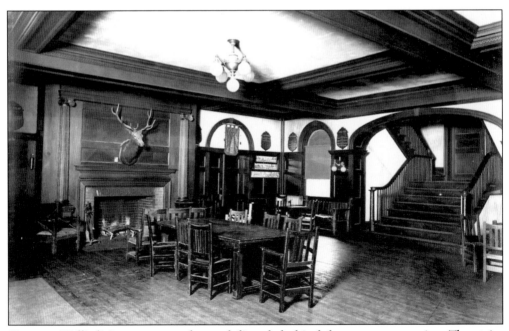

Hartman Hall's living room was located directly behind the entrance portico. The stairs led to the chapel, extending to the west of the building.

Four

A MODERN COLLEGE,

A COLONIAL REVIVAL CAMPUS
1909–1941

These years marked a distinct period in the college's history. In 1909, Henry Harbaugh Apple became the fifth president of Franklin & Marshall College. His 25-year tenure was an era of dramatic change: enrollment more than tripled, the size of the faculty tripled, and the endowment neared $1 million. Apple moved the college away from its roots in the Mercersburg Theology and replaced the classical curriculum with majors. He also introduced new academic programs in business administration and education, which prepared students for careers. Apple's successor, John A. Schaeffer, continued the process of modernization both in the curriculum and the fabric of buildings.

Between 1909 and 1941, the college added 10 new buildings in the Colonial Revival style, 7 designed by architect Charles Klauder. Although previous buildings had been designed in the Gothic, Tudor, High Victorian, and Beaux Arts styles, the *Franklin and Marshall Alumnus* reported in 1925 that "the trustees have decided that Colonial architecture is more representative of the small American college." Klauder's campus plan and the new buildings, organized around open or three-sided quadrangles, created an aesthetically unified campus.

During these years, the range of student extracurricular activities increased. Class rivalries manifested themselves in poster wars, tie-ups, and other contests; intercollegiate athletics flourished; the number of fraternities grew. The literary societies continued to thrive, and students created new organizations that expressed their academic interests, such as the Porter Scientific Society and Black Pyramid, as well as those that regulated student life, such as the Student Senate and the Inter-Fraternity Council.

Henry Harbaugh Apple (1869–1943), class of 1889, became the fifth president of the college in 1909. He presided over a period of substantial growth for the college: a tripling of the number of students and faculty, an energetic building program that transformed the campus, and a successful capital campaign to increase the endowment. Apple replaced the classical core with majors and introduced vocational programs in business and education.

Benjamin Franklin Fackenthal (1851–1941) was president of the college's board of trustees from 1915 until his death in 1941. A metallurgist and executive of several mining and manufacturing companies, he was a major benefactor of the college, donating funds for the construction of the new science building (1928–1929), the swimming pool (1930–1931), and the new library (1937–1938), as well as an endowed professorship in biology, all of which bore his name.

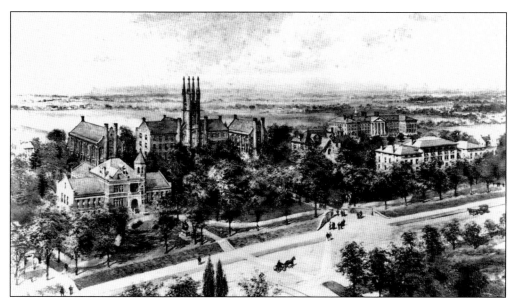

Richard Rummell's 1910 lithograph of the college depicts the campus at the beginning of Henry Harbaugh Apple's presidency.

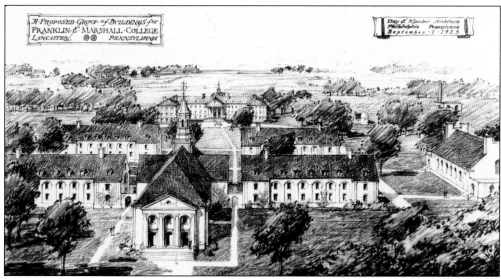

This September 1925 sketch illustrates the new campus envisioned by Apple and Charles Z. Klauder. The college erected Dietz-Santee and Franklin-Meyran Halls to the south of Hensel Hall, but not the identical two dormitories to the north. Hartman Hall is on axis with Hensel, while Biesecker Gymnasium is to the right. The *Franklin and Marshall Alumnus* described this complex of buildings as the "heart of the campus."

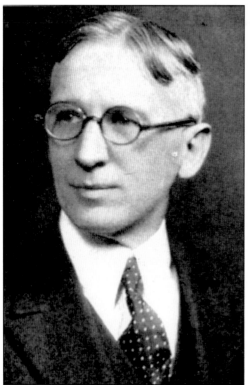

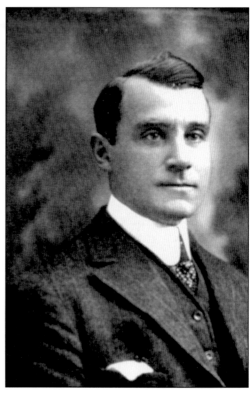

Harry M. J. Klein (above, left) served
as Audenried Professor of History
and Archaeology from 1911 to 1946.
Charles "Uncle Charley" Mayser
(above, right) was director of physical
education and a legendary wrestling
coach from 1913 to 1914 and from
1923 to 1947. John Nevin Schaeffer
(left) taught Greek from 1910 to 1942.

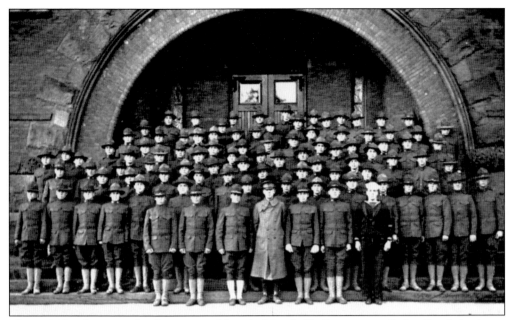

This 1918 photograph shows Franklin & Marshall Company of the Student Army Training Corps. During World War I, the War Department created the corps to enable young men eligible for the draft to continue their education. Students drilled each morning and afternoon and followed a curriculum, created by the War Department Committee on Education and Special Training, that combined military tactics with more traditional academics.

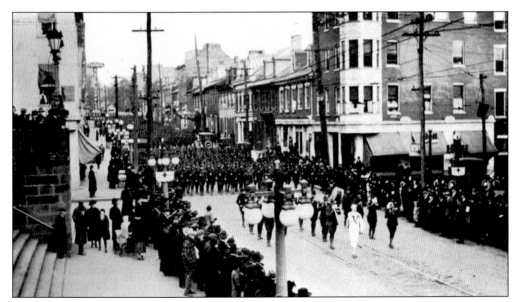

The Franklin & Marshall Student Army Training Corps marches on East King Street toward Penn Square. The SATC Band, led by drum major Paul C. McClement, precedes the student cadets. According to the 1920 *Oriflamme*, "whenever there was a big military parade or celebration the Corps with the splendid Band at their head were always the outstanding feature of the parade."

Philadelphia architect Charles Zeller Klauder (1872–1938) designed seven campus buildings and prepared the first master plan of the college between 1924 and 1931. Best known for his work in association with Frank Miles Day, Klauder was an extraordinarily prolific designer of educational buildings and was co-author of *College Architecture in America* (1929), the first important work devoted to the history and design of campus buildings.

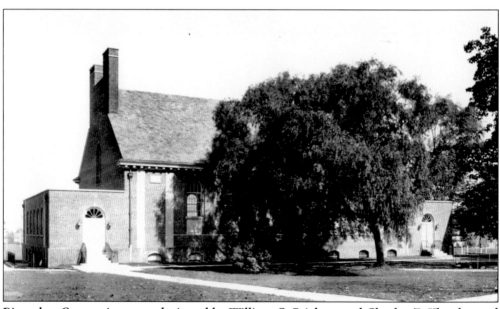

Biesecker Gymnasium was designed by William C. Prichett and Charles Z. Klauder and erected between 1924 and 1925. The gift of alumnus and trustee Fred W. Biesecker, class of 1880, this modern facility replaced the college's original gymnasium, which then became Campus House.

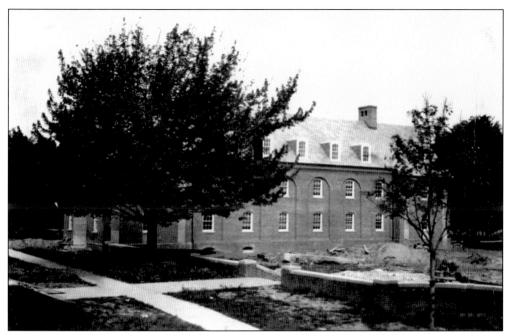

Dietz-Santee Hall, seen under construction in 1925, was the gift of Mary E. Santee in memory of her father, Charles Santee, and her fiancé, Jacob Y. Dietz. The wall and stairway extending toward Franklin-Meyran Hall marked the transition from the older, eclectic campus to the "new" Franklin & Marshall. The new dormitories were illustrated as noteworthy examples of Georgian-style collegiate architecture in the December 1925 issue of *Architectural Forum.*

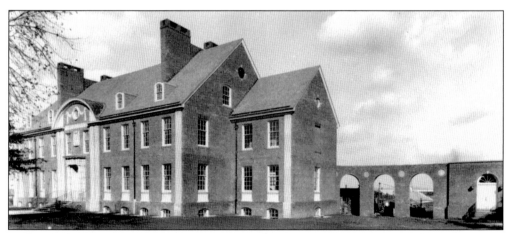

Fackenthal Laboratories, designed by Charles Z. Klauder and built at a cost of approximately $250,000 in 1928–1929, was another benefaction of B. F. Fackenthal Jr. It replaced the original Science Building (Stager Hall), erected between 1900 and 1902.

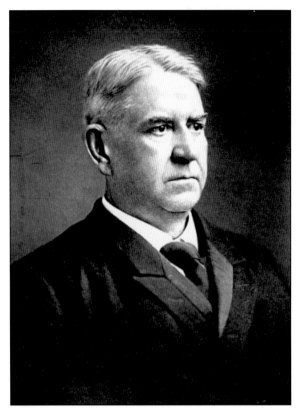

William Uhler Hensel Memorial Auditorium (below), designed by Charles Z. Klauder and erected between 1925 and 1927, was built as an 800-seat hall that could effectively accommodate the entire faculty and student body at the time. Hensel (left), class of 1870, was a prominent Lancaster attorney and historian. A longtime Franklin & Marshall trustee, he served as president of the board in 1914–1915. Hensel was the first president of the board who was not a member of the Reformed Church.

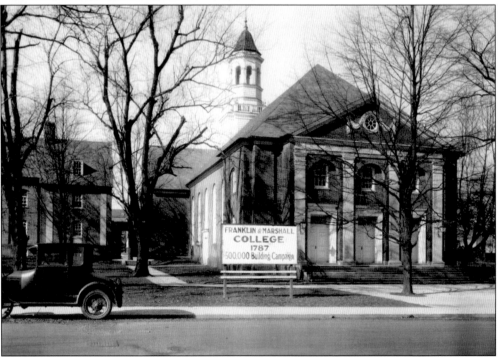

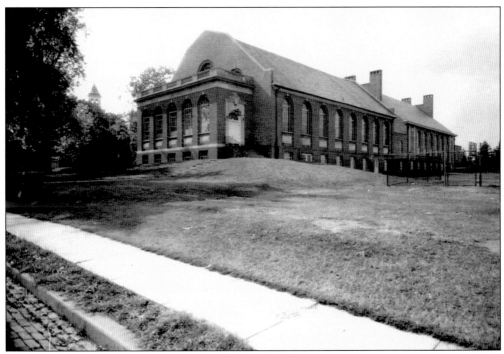

Given to the college by B. F. Fackenthal Jr., Fackenthal Pool was probably designed by Charles Z. Klauder. The photograph above illustrates the exterior as seen looking southwest from College Avenue. Below is the interior at the time construction was completed in January 1931.

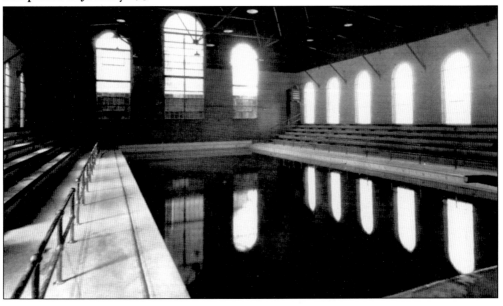

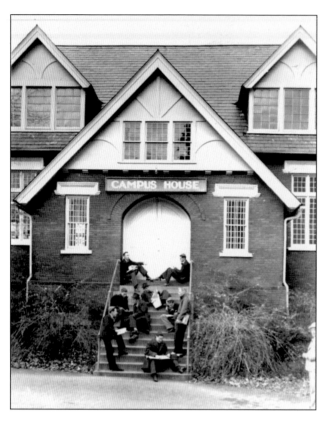

Students lounge on the steps of Campus House *c.* 1930. With the completion of Biesecker Gymnasium, the old gym was transformed into a student center. First suggested by Harold J. Budd and enthusiastically supported by students as well as by President Apple, Campus House opened in January 1927.

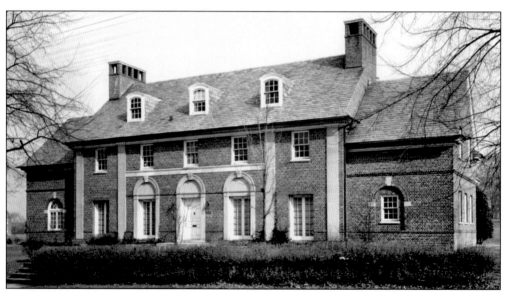

Dubbsheim, the Chi Phi fraternity house, was designed by Walter T. Karcher and Livingston Smith and erected in 1928. It was named in honor of Joseph H. Dubbs, who in 1854 became the first initiate of the chapter. President Apple hoped that other fraternities would build houses in a row extending from the Chi Phi house to Harrisburg Pike. During World War II, Dubbsheim served as a navy dispensary and sickbay.

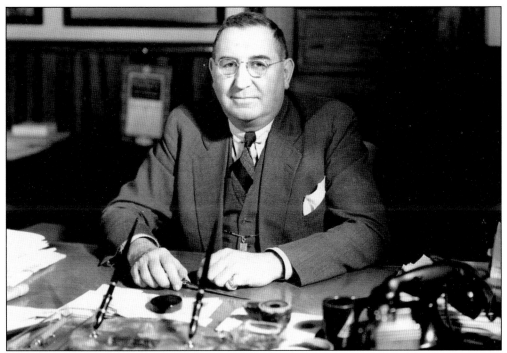

John A. Schaeffer (1886–1941), class of 1904, became the sixth president of Franklin & Marshall in June 1935. He received a doctorate in chemistry from the University of Pennsylvania in 1908 and worked in industry until his appointment as president. Following his sudden death, the faculty honored Schaeffer as a president who "immediately won our highest esteem and regard for his unbounded energy and enthusiasm in the performance of his duties."

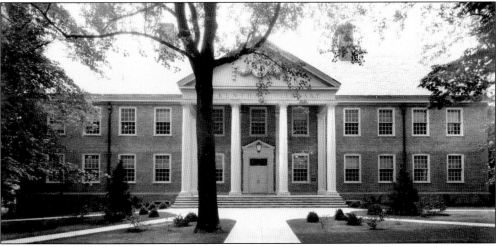

Fackenthal Library was designed by Philadelphia architect William Lee and built between 1937 and 1938. The library provided study space for 300 students and shelf space for 200,000 books. At the dedication of the new library, B. F. Fackenthal Jr. expressed sadness over the demolition of Watts DePeyster Library. The original plan had incorporated part of the old library within the new, but the discovery of "defective walls and foundations" made this impossible.

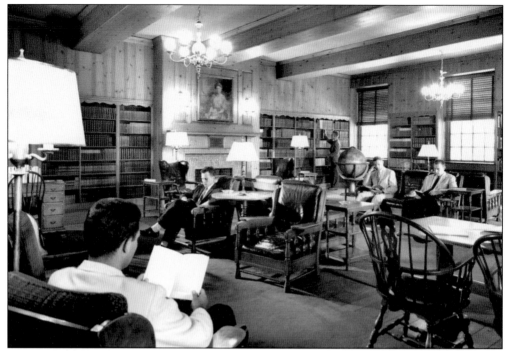

The Browsing Room at Fackenthal Library was given by Dr. Frank D. Fackenthal in honor of his uncle. The portrait on the chimney breast depicts Sarah Riegel Fackenthal, wife of B. F. Fackenthal Jr.

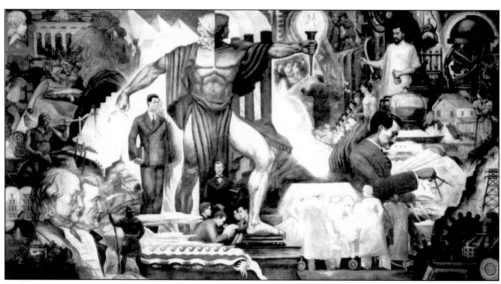

Research, Practical and Philosophical, Looks to the Past and Future in Generations of Men, by John C. Wonsetler, was originally placed in the lobby of Fackenthal Library in 1938. It was then moved to the Reference Room in 1983. The central figure, Janus, looks backward (left) to the age of handcrafts and agriculture, and forward (right) to the age of modern industry, medicine, and science. Note the college torch in Janus's left hand.

Keiper Memorial Liberal Arts Building (below), designed by William Lee and erected in 1936–1937, was a gift by Caroline S. Keiper in memory of her husband, Lanious B. Keiper. He had been a member of the board of trustees of the college from 1910 to 1917. Judge Benjamin Champneys Atlee presided at the dedication of the building (right), during the college's sesquicentennial celebration on October 16, 1937.

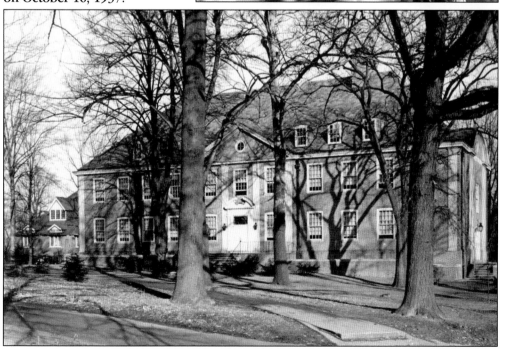

63

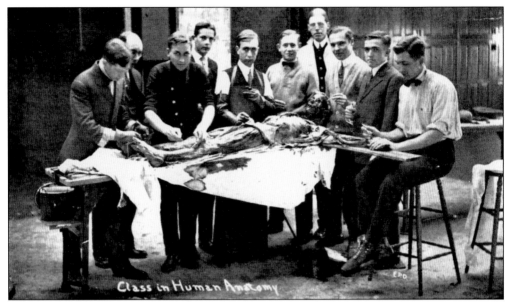

This class in human anatomy dissects a cadaver. Prof. Richard Schiedt (second from left) taught the class along with Charles Patterson Stahr (seventh from left), who was the son of John S. Stahr and a well-known Lancaster physician. When published in the 1911 *Oriflamme*, this photograph was captioned "A Stiff Proposition."

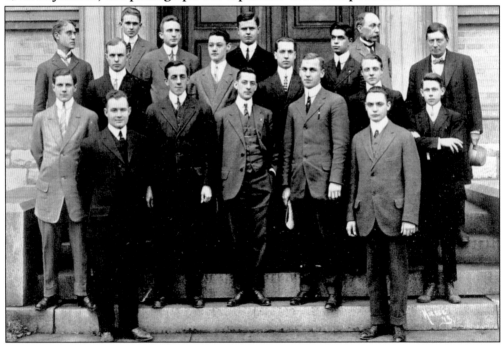

The Porter Scientific Society was organized by Richard Schiedt and Jefferson Kershner in 1910 to promote student interest in science. It was named in honor of Thomas Conrad Porter, the first professor of natural science at Franklin & Marshall and a well-known botanist. In this 1914 photograph, Schiedt appears in the back row, second from the right. Kershner stands in the back row at the right.

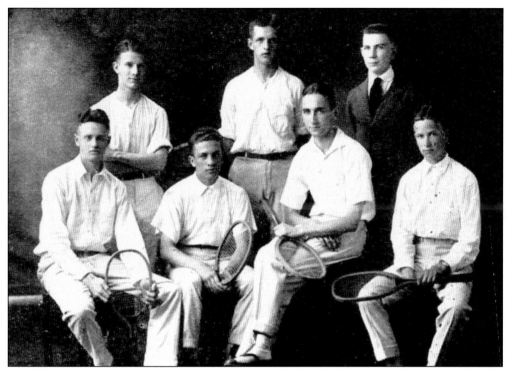

In this image of the 1919 tennis team, captain Henry F. Myers Jr. is third from the left in the first row, and manager John D. Kocher stands at the right. Other team members are W. P. Brinton, N. E. Hager, W. K. Henry, F. S. Miller, and R. F. Mehl. According to the 1921 *Oriflamme,* "tennis was by far the most successful sport at F. & M. during the past year."

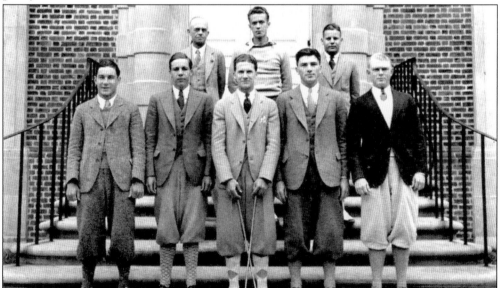

The 1931–1932 golf team was led by captain Raymond Albright, who stands in the center of the first row. Victor W. Dippell, professor of German and coach of the team, stands in the second row on the left.

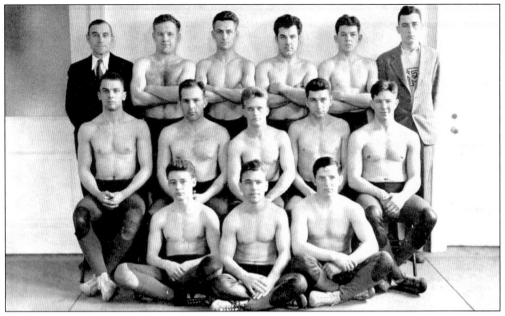

Under the leadership of coach Mayser, the wrestling team went undefeated in the 1931–1932 season. Pictured here are, from left to right, the following: (first row) J. Gehr, R. Bleakley, and F. Horner; (second row) C. Hauer, E. N. Allan, P. M. Hollinger (captain), P. Cassel, and J. Strachan; (third row) C. W. Mayser (coach), W. Breisch, E. Highberger, C. Richards, R. Phillips, and G. D. Patterson (manager).

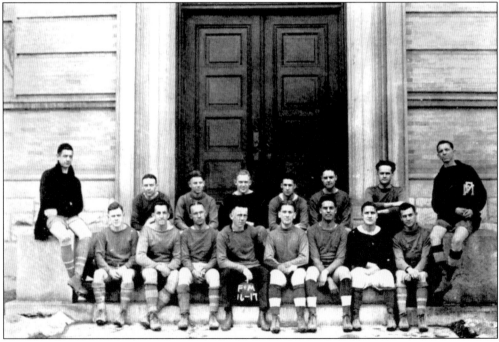

The 1916–1917 soccer team poses in front of the Science Building (Stager Hall). Organized in 1911 as a team in the Lancaster District Soccer League, soccer became an intercollegiate sport at Franklin & Marshall in 1926.

Gordon Chalmers, class of 1935, competed in the 100-meter backstroke at the 1932 Olympics. On March 25, 1933, Chalmers won the 150-yard backstroke title at the National Intercollegiate Swimming Meet held at Yale University.

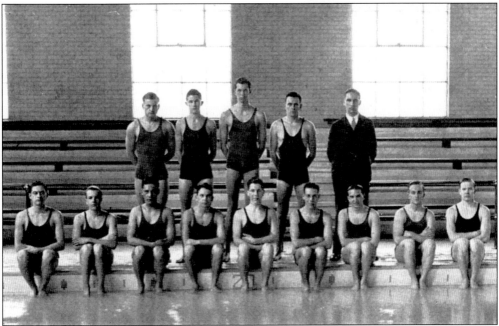

The 1931–1932 swimming team included co-captains Robert E. Hoar and A. Groh Schneider (first row, fourth and fifth from left, respectively). Standing at the center is Gordon Chalmers.

The college band stands at the entrance to the Lancaster Theological Seminary in this 1923 photograph. Carl H. Galloway directed the student musicians.

The 1921 cheerleaders included, from left to right, Richard Wagner, Charles Brown Clinard, and P. Hermany Dyatt.

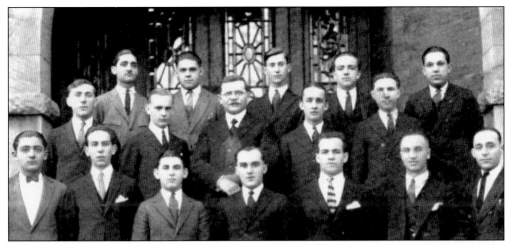

To educate the sons and grandsons of Hungarian immigrants who were members of the Reformed Church, the college established a program in Hungarian language, literature, and history in the fall of 1922. It was the only American college with such a program. Alexander Toth, who taught Hungarian at the college and at the Lancaster Theological Seminary, stands at the center of the second row, surrounded by Hungarian students in this 1925 photograph.

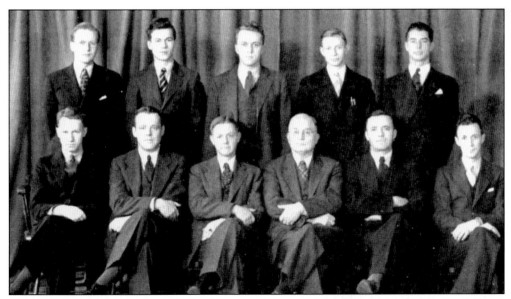

The Calumet Club was the premier literary society of the 1930s. Founded by Prof. Sivert N. Hagen (first row, fourth from left), it included young faculty and their most talented students. Each fortnightly meeting focused on a paper presented by a member. Richard Altick (seated at left) read a paper entitled "American Best Sellers, 1876–1935" during the academic year 1935–1936. He later became regents professor of English at Ohio State University.

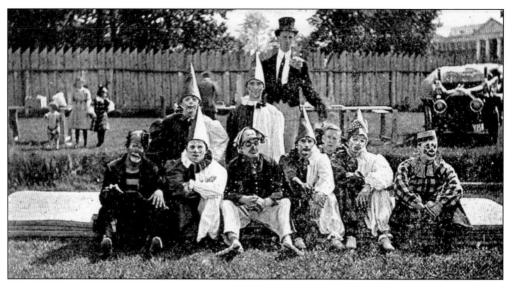

The College Circus was organized in 1912 by Prof. D. McLaughlin, physical instructor and director of the college gymnasium. After a parade through the city, students returned to Williamson Field, where they performed various athletic, acrobatic, and humorous stunts. *Oriflamme* described the "work of the clown acrobats" as "especially commendable, not only on account of their genuine skill, but also for their comic action and ludicrous costumes."

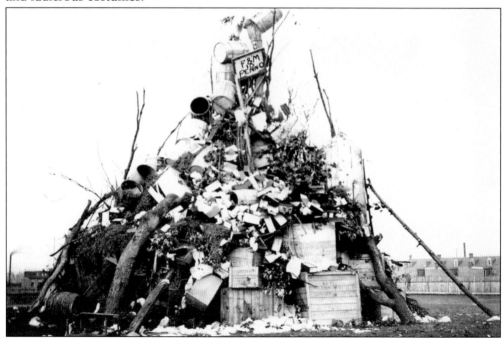

The bonfire is "ready for the torch" in celebration of Franklin & Marshall's 10-0 victory over the University of Pennsylvania football team on October 3, 1914. Two days after the historic game, the student body marched to Penn Square and then to Williamson Field, where, *F&M Weekly* reported, "a monster concourse of people assembled to witness the students give vent to their feelings of joy."

Poster wars were organized as ways of building class loyalties at a time when only a small percentage of students lived on campus. Sophomores initiated the annual contest by hanging hundreds of posters throughout the city. This poster, from the fall of 1922, established rules of behavior for first-year students. The freshmen responded by tearing down the posters and replacing them with ones offensive to the sophomores.

ATTENTION ABSORB

1. Wear a blue cap with a green button on top.
2. Keep off the grass on the campus.
3. Wear green ties and black socks at all times.
4. Do not walk or speak to girls at any time.
5. Keep off the streets after 8 P. M. on week days and after 10 P. M. on Saturdays and Sundays.
6. Carry matches at all times.
7. Do not smoke on the campus or in buildings.
8. Show respect to Seniors at all times.
9. Be present at all mass meetings and athletic contests.

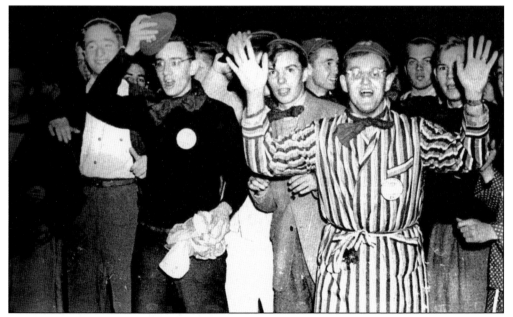

Unidentified first-year students participate in the Pajama Parade, a rite of passage for generations of undergraduates. Note the "dinks," or caps, that were required apparel for freshmen through the 1930s.

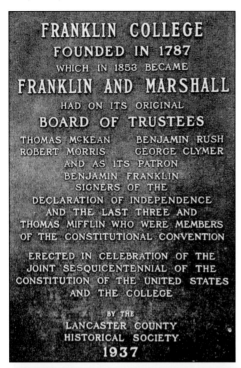

FRANKLIN COLLEGE
FOUNDED IN 1787
WHICH IN 1853 BECAME
FRANKLIN AND MARSHALL
HAD ON ITS ORIGINAL
BOARD OF TRUSTEES
THOMAS McKEAN BENJAMIN RUSH
ROBERT MORRIS GEORGE CLYMER
AND AS ITS PATRON
BENJAMIN FRANKLIN
SIGNERS OF THE
DECLARATION OF INDEPENDENCE
AND THE LAST THREE AND
THOMAS MIFFLIN WHO WERE MEMBERS
OF THE CONSTITUTIONAL CONVENTION

ERECTED IN CELEBRATION OF THE
JOINT SESQUICENTENNIAL OF THE
CONSTITUTION OF THE UNITED STATES
AND THE COLLEGE

BY THE
LANCASTER COUNTY
HISTORICAL SOCIETY
1937

This sesquicentennial plaque was erected by the Lancaster County Historical Society in 1937 to mark the 150th anniversary of the Constitution and the founding of Franklin College. The plaque was originally affixed to a pier of the college gate (now Marshall Gate).

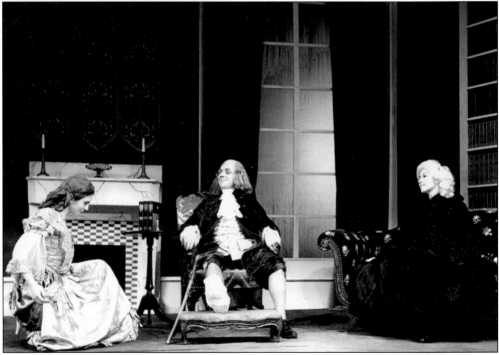

Another event in the sesquicentennial celebration was the production of Louis Evan Shipman's three-act play *Poor Richard,* which was directed by Darrell D. Larsen. John S. Neal, class of 1939, played Franklin. This was the first play produced in the Green Room Theater, constructed on the lower floor of Keiper Liberal Arts Building in 1937.

Five

WAR, PEACE, AND
A TIME OF PROSPERITY
1941–1962

The year 1941 brought a new president to the college, Theodore A. Distler, and a new challenge: following the Japanese attack on Pearl Harbor, the United States entered World War II. As millions of American men joined the military, all institutions of higher education faced an enrollment crisis, though for all-male colleges the challenge was greatest. Distler and Shober Barr successfully lobbied to have the college designated a site of navy V-5 and V-12 programs, which kept Franklin & Marshall alive for the duration of the war.

Peace brought a different set of challenges. The Servicemen's Readjustment Act of 1944 (the G.I. Bill) paid up to $500 for tuition and books, as well as a monthly living allowance, to enable veterans to attend college. Enrollment soared to record levels in the aftermath of the war. In the fall of 1947, two-thirds of Franklin & Marshall's students were veterans. Married students lived in East Hall. The presence of so many veterans on campus restrained the traditional hazing of new students and class rivalries.

"Prexy" Distler resigned from the presidency in 1954 and was succeeded by William W. Hall, who left the college after two years because of poor health. Frederick Bolman, the ninth president, introduced sweeping changes to the curriculum that affirmed the centrality of the liberal arts to the college's mission. He also enhanced the professionalism of the faculty. The college erected two new dormitories (which increased the percentage of students living on campus), constructed the Charles W. Mayser Physical Education Center and the Appel Infirmary, renovated and enlarged Stahr Hall, and erected an addition to Fackenthal Laboratories.

This was a period of distinguished success for many of the college's 11 athletic teams: the 1950 football team went undefeated, and the 1952 soccer squad captured the national championship. Students participated in a wide array of organizations, both academic and social. Homecoming became a major event, as did the Winter Weekend dance and the spring Interfraternity Ball.

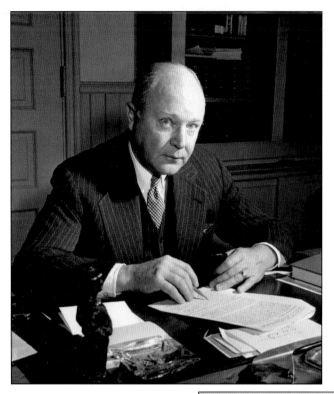

Theodore A. Distler (1898–1991) was named the seventh president of Franklin & Marshall in 1941. At a time when most young men were in the military, he succeeded in having the college chosen as a site for U.S. Navy V-5 and V-12 officer training programs. During his presidency, Distler oversaw the continuing evolution of the college and a substantial increase in endowment.

Frederick deWolfe Bolman Jr. (1912–1985) became the ninth president of the college in 1956. His brief presidency was a time of dramatic change at the college: Bolman raised the level of professionalism of the faculty, instituted merit salary increments and sabbaticals, and oversaw the development of a new curriculum. Bolman clashed with board president William A. Schnader and resigned under duress in September 1962.

Anthony R. Appel (1915–1997), class of 1935, a prominent Lancaster attorney, was named 10th president of the college at the meeting when the board of trustees forced Frederick Bolman's resignation. Faculty were so upset, both over the board's treatment of Bolman and the absence of process in selecting his successor, that Appel found his position untenable: he resigned six days after being named president. Dean Wayne Glick then served as acting president.

James M. Darlington (1908–2000), class of 1930, completed a doctorate in biology at Brown University. Appointed an instructor in 1937, he was named B. F. Fackenthal Professor of Biology in 1951. He served as dean of the college from 1955 to 1961 and in a number of administrative positions in succeeding years. Beloved as a teacher and colleague, Darlington was, according to President Bolman, "a tireless worker, a fearless innovator, and our intellectual leader."

75

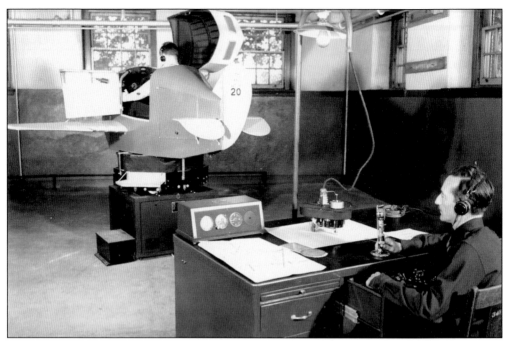

Professor of history Frederic S. Klein, seated at the desk, observes a student in the Link Trainer. Klein served as faculty adviser to the Aero Club, which organized during the 1937–1938 academic year. Although the club was intended to appeal to students interested in aviation, by 1942 its membership was students enrolled in the Civilian Pilot Training Program. Many pilots trained through this program joined the U.S. air forces during World War II.

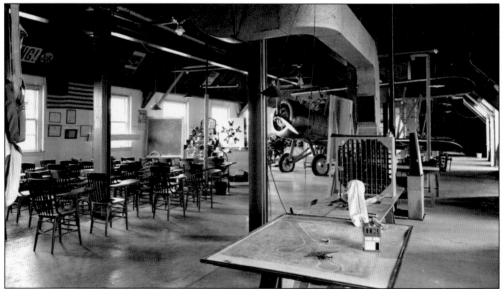

An aeronautical laboratory and classroom occupied the third floor of Keiper Liberal Arts Building for Navy Aviation programs between 1942 and 1945. The plane, a navy Corsair observation biplane, was carried up to the third floor in pieces and assembled by student members of the Aero Club.

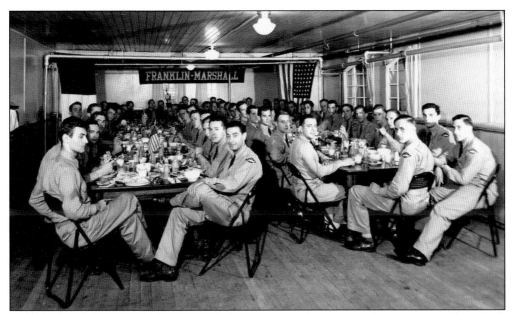

Navy cadets in the V-5 and V-12 programs ate meals at one of two mess halls, which were located in both the old (East Hall) and new (Hartman Hall) academy buildings.

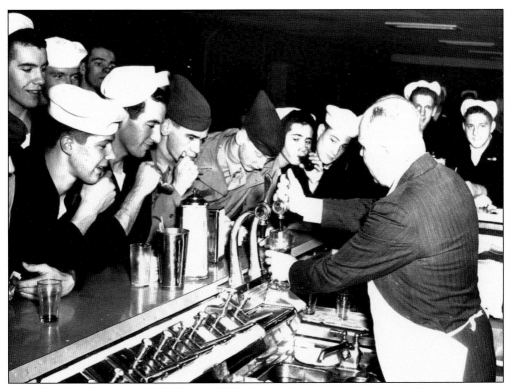

President Distler serves U.S. Navy and Marine cadets in the snack bar at Campus House *c.* 1943.

Marshall-Buchanan Residence Hall, designed by William Lee and named in honor of John Marshall and James Buchanan, was dedicated on October 20, 1956.

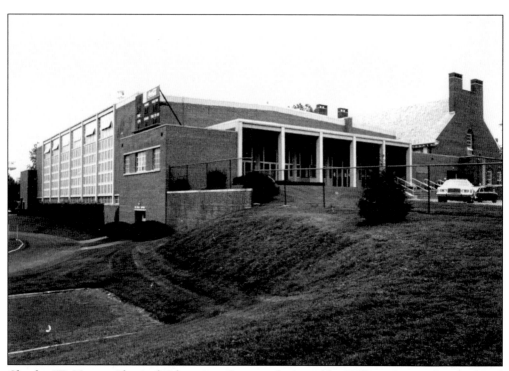

Charles W. Mayser Physical Education Center, designed by William Lee and completed in 1962, was named in honor of Mayser, director of physical education from 1938 to 1945 and wrestling coach for more than 20 years. The dedication program recognized Mayser for the "tradition for excellence in health and athletics which he nurtured here and the high esteem in which he is held by thousands of Franklin and Marshall men."

Historian Bruce Catton (seated) spoke at the college on November 1, 1962. He discussed the significance of the Emancipation Proclamation with students in the Browsing Room of Fackenthal Library. Standing is William H. Gray, class of 1963, later a leading member of the U.S. Congress and president of the United Negro College Fund.

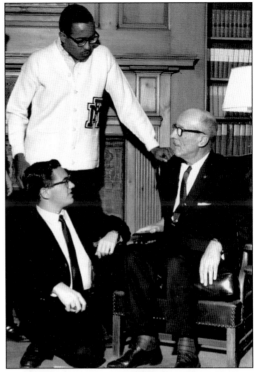

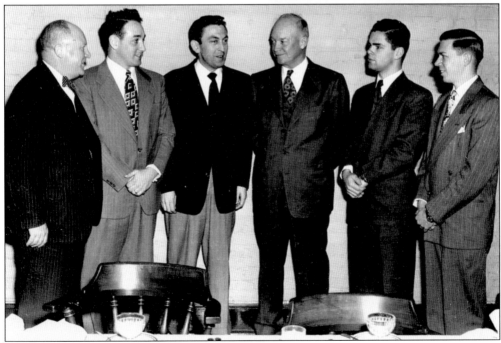

Pres. Theodore Distler (left) and student leaders John McManus, Charles Thompson, John Hughes, and John Smith meet with Dwight D. Eisenhower (fourth from left), then president of Columbia University, on March 2, 1950. (Courtesy of Lancaster Newspapers Inc.)

Chemistry department professors gather in Fackenthal Laboratories in 1959. From left to right are Gary D. Eisenberger, Robert P. Cross, Hugh A. Heller, Austin J. Rich, Frederick H. Suydam, Fred A. Snavely, Ruth W. Van Horn, and Colin E. Fink.

Government department professors pose for an *Oriflamme* photographer in 1959. From left to right are Richard F. Shier, John H. Vanderzell, and Sidney Wise.

First-year students lived in dormitory rooms in Hartman Hall. The student in the foreground is wearing a dink, identifying him as a member of the class of 1964. The portrait is of Thomas Gilmore Apple, the third president of the college.

Oriflamme's caption for this 1959 photograph read, "Qualitative analysis of unknowns requires many hours of monotonous work for the sophomore pre-med." At the right is Murray H. Seltzer, class of 1961, who went on to study medicine at the University of Pennsylvania and a career as a surgeon.

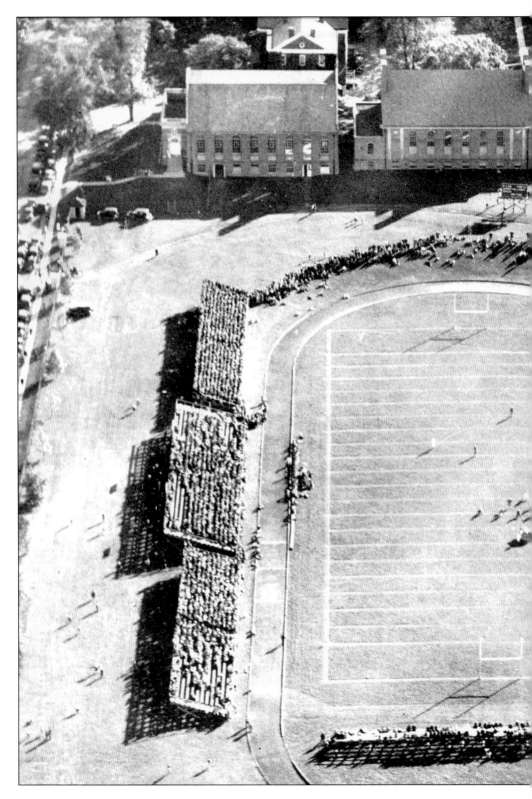

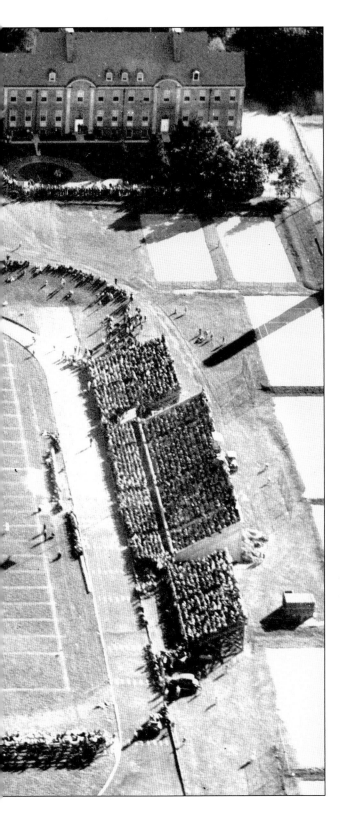

Crowds thronged Williamson Field for football games in the years after World War II. Football was so popular that the November 10, 1951, game against Washington & Jefferson College was broadcast regionally by WGAL as part of the NCAA's effort to assess the impact of television on attendance. This was the only game between two small colleges telecast as part of the NCAA study and may have been the first telecast of a small college football game. The 1950 team completed the first undefeated season in school history. This photograph was taken in the mid-1940s.

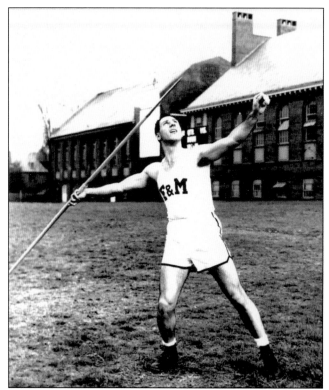

William Iannicelli, class of 1948, was co-captain of the track-and-field team, Franklin & Marshall outstanding athlete of the year, a two-time All-American, and an alternate on the 1948 U.S. Olympic team for javelin. Iannicelli returned to the college in 1949 as a coach.

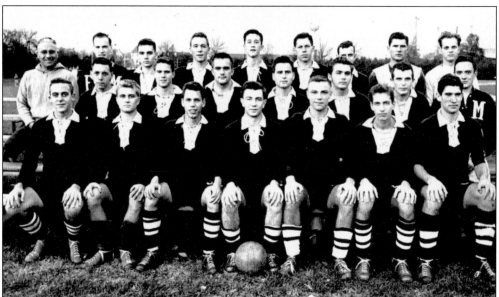

Franklin & Marshall's undefeated 1952 soccer team was coached by Robert Smith (third row, far left). The National Intercollegiate Soccer Coaches Association voted Franklin & Marshall the outstanding team in the nation over other regional champions Dartmouth, Duke, the University of Baltimore, Oberlin, and the University of San Francisco. Carl Yoder (first row, seventh from left) was named first team All-American; Walt Lenz (third row, seventh from left) received honorable mention.

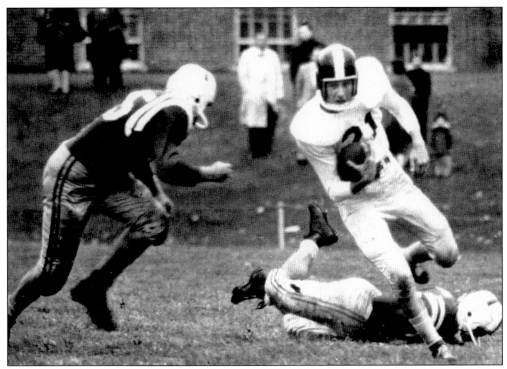

Described in *Oriflamme* as "fleet, elusive, and spirited," freshman halfback John Betrone runs for a touchdown against Albright on October 25, 1958.

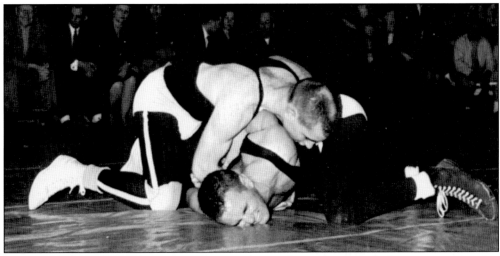

Wrestling co-captain Cleon Cassell grapples with an unidentified opponent in this 1960 photograph.

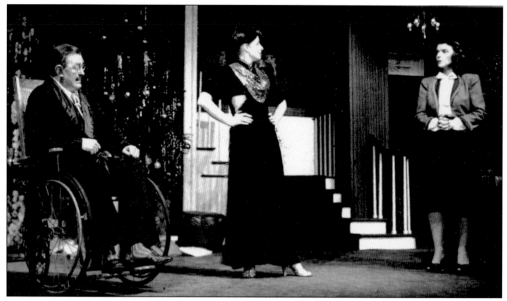

Darrell D. Larsen (in wheelchair), longtime director of the Green Room Club, took to the stage as Sheridan Whiteside (modeled on Alexander Woollcott) in the May 1944 production of George S. Kaufman and Moss Hart's *The Man Who Came to Dinner.*

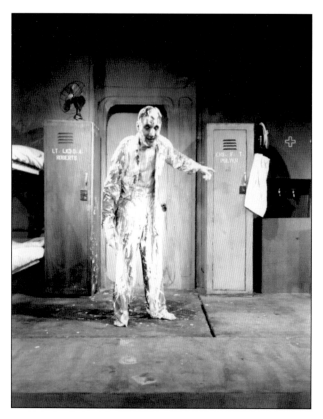

Roy Scheider, class of 1955, plays the role of Ensign Pulver in the Green Room's 1954 production of *Mister Roberts.* Following graduation, Scheider studied acting and performed repertoire theater in New York, where he won an OBIE in 1968. In a distinguished career as an actor, he was nominated for Oscars for his supporting role in *The French Connection* (1971) and as best actor in *All That Jazz* (1979).

Stunt Night, a spring competition organized by Alpha Delta Sigma in 1938, was a popular annual event. Fraternities and other groups presented skits or songs that were humorous (or that aspired to be so). The final Stunt Night took place in 1958. According to *Student Weekly* writer Paul Leventhal, "sadistic wit and perverse burlesque ran rampant last Wednesday evening." Leventhal later became founding president of the Nuclear Control Institute.

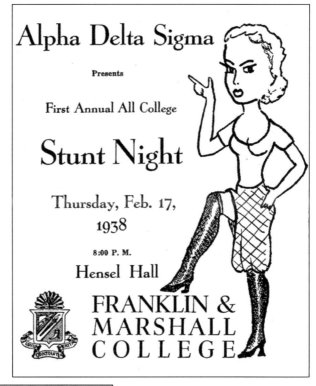

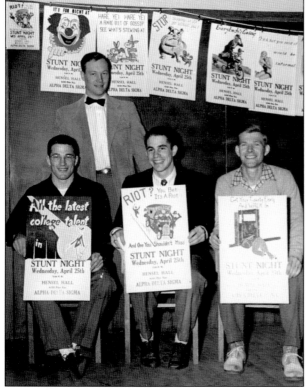

Students in Prof. Noel P. Laird's management class prepared posters advertising Stunt Night. The winners of the 1956 competition are, from left to right, Lloyd S. Greiner (first prize), Russel F. Welsh (third prize), and Robert H. Parker (second prize).

87

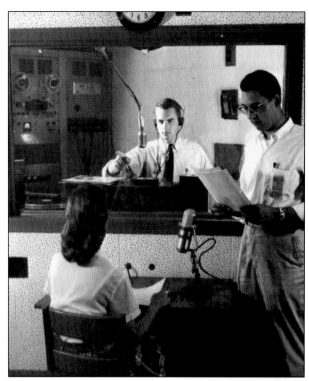

Two unidentified students and a woman are pictured in the sound room and control room of WWFM, the college's student-run radio station, located in the basement of Hartman Hall. This photograph was taken in 1960.

The Skiing and Outing Club organized during the 1954–1955 academic year to provide opportunities to young men "interested in outdoor activities other than the major sports offered by the school."

The college band rehearses in its second-story room in Diagnothian Hall in the 1950s. John H. Peifer Jr. (left) conducts.

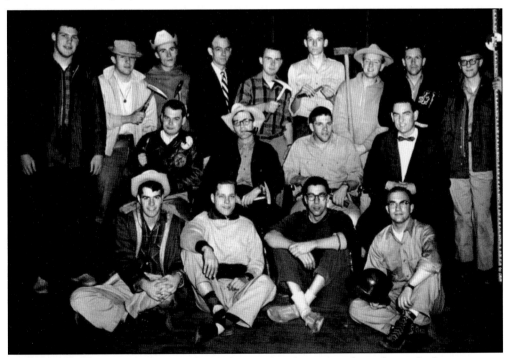

Student members of the Geological Society are armed with rock hammers, a sledgehammer, and a stadia rod (used in surveying) in this 1960 photograph. Prof. Jacob Freedman sits second from left, and Prof. Marvin Kauffman sits at the right.

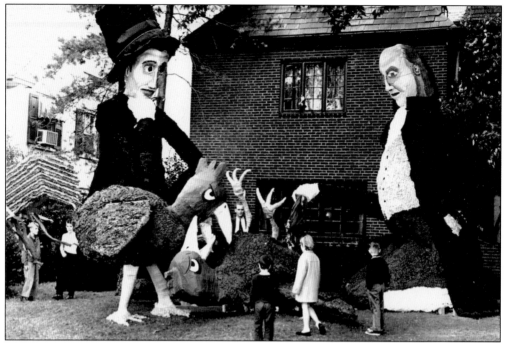

Lambda Chi Alpha won the coveted Homecoming Prize on October 28, 1961. The display, entitled "Diplomacy," presents John Marshall and Benjamin Franklin, each 20 feet tall, observing a fight between two bantams. The bantam was the mascot of Trinity College, which played the Diplomats in football that day. (Courtesy of Lancaster Newspapers Inc.)

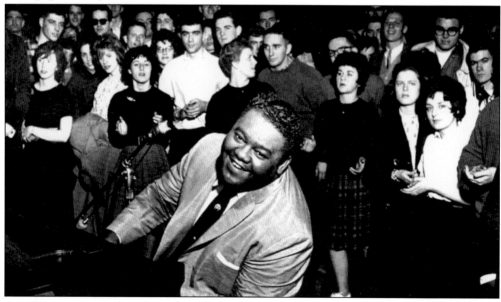

Fats Domino "took the place by storm" on the Saturday of Snowball Weekend, February 24, 1962. The dance was held in the new Mayser Center, which the *Student Weekly* described as "an ethereal Valhalla." Duke Ellington had also performed there on Friday evening.

Six

YEARS OF CRISIS AND CHANGE
1963–1983

Between 1963 and 1983, the college wrestled with the long-debated question of whether to become coeducational, experienced the student unrest of the late 1960s and early 1970s as well as a financial crisis that resulted in the elimination of faculty positions, revamped the curriculum, and met the challenge of a post–baby boom time of scarcity in college-age students.

Pres. Keith Spalding captured the ambivalence of much of this period in a letter to the class of 1972. He acknowledged the emotional turmoil of the students' years at the college—a moratorium in protest against the Vietnam War in October 1969, which was followed by many other protests; the furor over the decision not to rehire history instructor Henry Mayer in the spring of 1970, which was followed by a student sit-in in East Hall, then the administration building; and the campus's response to the killing of four Kent State students by an Ohio National Guard unit—but stated that while outsiders might think of the college as a place out of step with the rest of society, he found the vast majority of students to be thoughtful, concerned, and pleasant people.

Spalding was right. Franklin & Marshall students accomplished much in these years: they continued to thrive in traditional areas of strength such as the pre-healing arts, sciences, government, and business, and also developed much stronger commitments to the arts and social sciences. They regularly won Danforth Fellowships and other prestigious awards and continued the tradition of success in graduate study in the natural sciences. The student body was more diverse racially than at any previous time in the college's history, and students were engaged in a breathtaking array of activities that ranged from politics to music to drama to science and hobbies. Athletic teams had a series of successes, including NCAA championships, All-American recognition, and the 1972 Lambert Bowl, the symbol of supremacy in Division III football in the east.

When Keith Spalding retired as president in 1983, the college had emerged from the ordeal of the 1960s and 1970s with a stronger faculty, a new curriculum, a significantly improved physical plant, and a stronger financial base. It was poised for new challenges as it became recognized as a national liberal arts college.

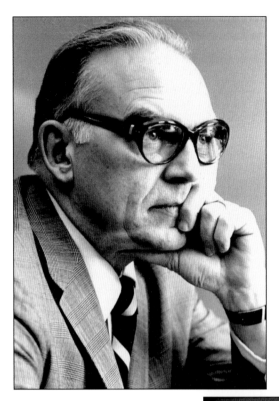

Keith Spalding (b. 1921) was named 11th president of the college in 1963. A journalist, he had been assistant to Pres. Milton Eisenhower at Penn State and Johns Hopkins, where he was also secretary of the university. Spalding presided over the transition to coeducation, years of student unrest, and fiscal challenges. During his tenure, the size of the student body doubled and the college adopted a new general education curriculum.

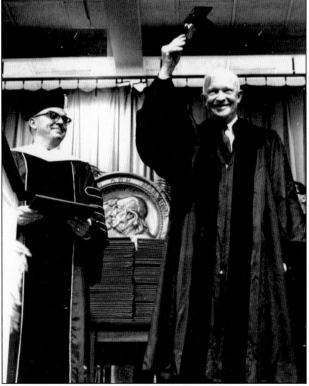

Former president Dwight D. Eisenhower tips his hat to the audience at the June 2, 1963, commencement. Eisenhower urged graduates to become engaged citizens. He attributed America's leadership not only to military and economic power but to "our intellectual strength, and beyond all this . . . our moral strength—our spiritual strength." Keith Spalding stands to the left.

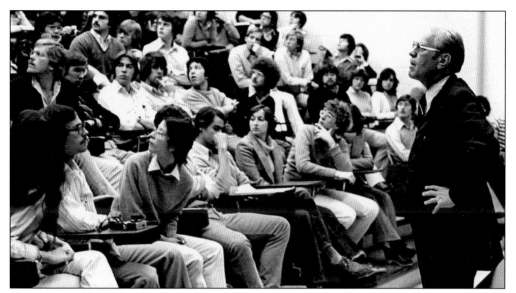

Former president Gerald Ford visited the campus on April 27, 1978. During his visit, which was sponsored by the American Enterprise Institute, Ford delivered a speech entitled "Energy, the Environment, and the Economy" in Kauffman Lecture Hall (above). He also gave speeches entitled "The President and the Congress" and "The President and Foreign Policy" and conducted a faculty seminar on development and political issues in Africa.

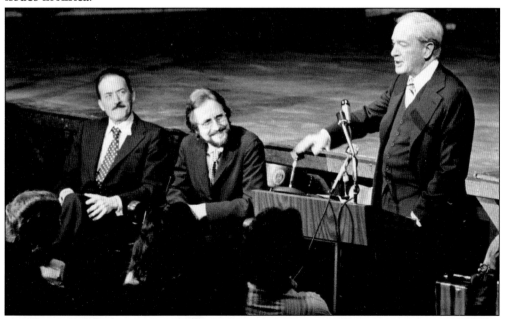

Franklin J. Schaffner, class of 1942, addresses students in the Green Room while actor Gregory Peck (left) and Prof. Gordon Wickstrom (center) listen. Schaffner and Peck were in Lancaster County filming scenes for *The Boys from Brazil*, which Schaffner directed. The two received honorary degrees at a special convocation on December 4, 1977. Also honored was actor Sir Laurence Olivier. *The Boys from Brazil* premiered in Hensel Hall on September 27, 1978.

The Gustavus Adolphus Pfeiffer Science Complex, designed by William Lee, was dedicated on September 19, 1969. At the convocation, the college conferred honorary degrees on Harold C. Urey, who was awarded the Nobel Prize in 1934 for his discovery of heavy hydrogen (deuterium); William Pecora, director of the U.S. Geological Survey; and J. Tuzo Wilson, former president of the International Union of Geodesy and Geophysics.

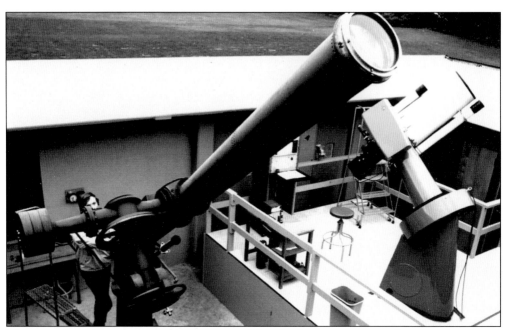

The Joseph R. Grundy Observatory, named for the businessman and U.S. senator, was erected on Baker Campus between 1967 and 1968. The observatory was equipped with a new 16-inch reflecting telescope and an 11-inch Repsold-Clark refractor telescope that had been used in the Daniel Scholl Observatory.

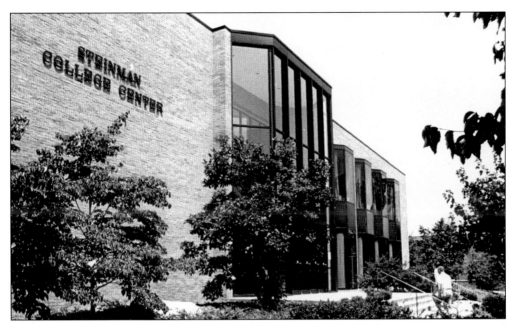

The Steinman College Center, designed by Minoru Yamasaki and Associates and completed in 1976, was named for James Hale Steinman and John Frederick Steinman, publishers of Lancaster's three newspapers and prominent philanthropists, in recognition of "their service to the community and to the College."

In 1982, the board of trustees voted to rename Fackenthal Library in honor of Arthur and Katherine Shadek and their family, who had provided funding for a new wing and renovations to the library, as well as for scholarships and endowed professorships. In this view, Arthur J. Shadek speaks at the dedication of Shadek-Fackenthal Library on October 15, 1983.

Although some members of the college community had advocated becoming coeducational for decades, the Task Force on Coeducation did not recommend the college admit female students until 1968. Students were among those most insistent on the change. In the photograph to the left, Eugene Hall, class of 1969, presents a petition in support of coeducation to Robert Sarnoff (far left), chairman of the board of trustees. Keith Spalding, who supported coeducation, stands between Sarnoff and Hall. Below, Spalding reads a sign in support of coeducation on the campus protest tree *c.* 1968.

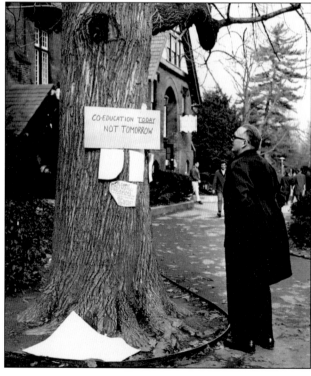

Students created a tombstone for their "classmate" Monas T. Cism in the spring of 1969 near the campus protest tree. The tombstone makers were apparently unaware that Franklin College had been coeducational, or they would have dated the stone 1853–1969.

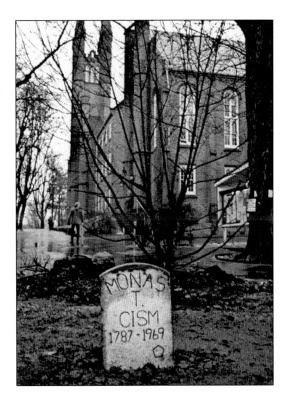

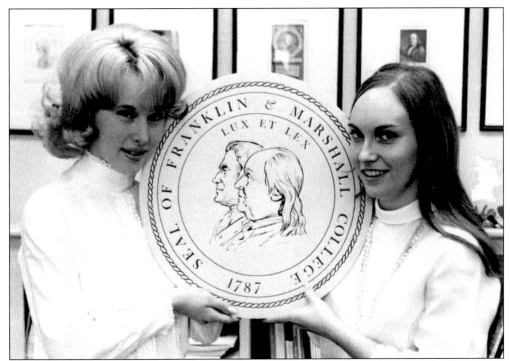

Two of the first female full-time students, Annette Rineer and Linda Geist, hold the seal of the college in 1969.

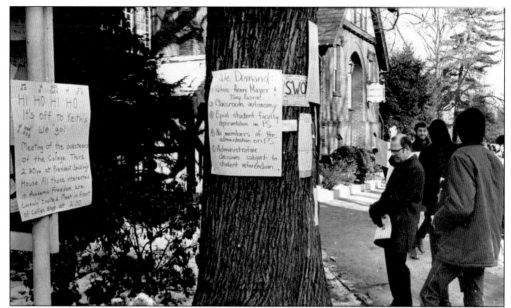

In early 1970, the college refused to rehire two popular instructors, Henry Mayer in history and Anthony Lazroe in sociology. The poster on the protest tree demanded the rehiring of the two instructors and other changes, including equal student-faculty representation on the Professional Standards Committee. In this photograph, Prof. Glenn Miller of the history department reads the postings.

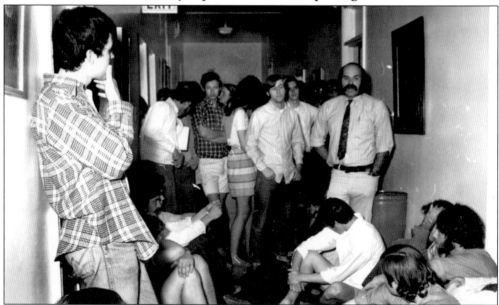

When the Professional Standards Committee and the history department deadlocked, on April 30, 1970, President Spalding announced that there would be no history appointment for the following year. More than 100 students occupied East Hall, then the administration building, in protest. Students and faculty raised approximately $10,000 to hire Mayer (standing at right) as "People's Professor" for the 1970–1971 academic year.

Following the American invasion of Cambodia that began on April 30, 1970, college campuses across the nation erupted in protest activities. On May 4, 1970, National Guard troops fired into a crowd of students at Kent State University, killing four and wounding nine. An enormous anti-war banner hanging from the top of Hartman Hall lists the American casualties in Vietnam, Cambodia, and Kent, Ohio, and asks, "What Next?" in this 1970 photograph.

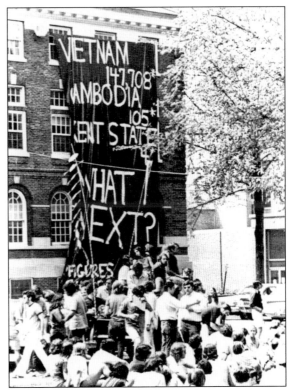

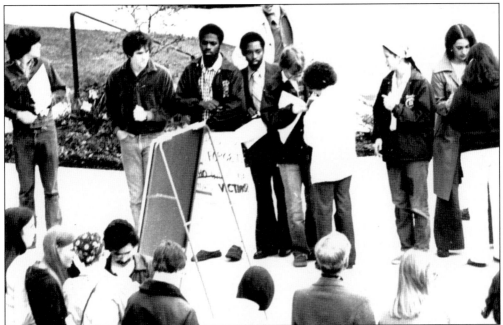

On April 20, 1978, Hillel sponsored a silent demonstration against racism. The demonstration took place on the birthday of Adolf Hitler, the same date on which members of the Nazi Party planned to march on Skokie, Illinois, a suburb with a large Jewish population.

John Stevenson (left) and Chris Black (right) were All-Americans in 1971 and 1972 and the first national wrestling champions in the college's history. They won their weight classes in the NCAA Small College Wrestling Tournament, held in Fargo, North Dakota, on March 13, 1971.

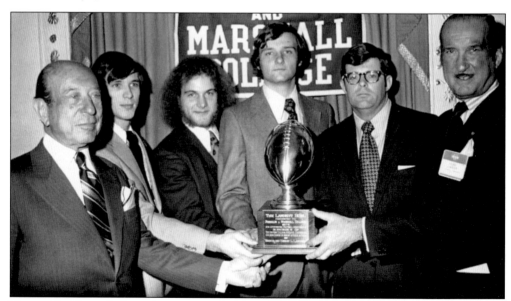

Vincent Lambert (left) and Henry Lambert (right) present the Lambert Bowl, symbolic of supremacy in Division III Eastern football, to tri-captains Dan Trusky, Craig Marks, and Bob Olender on December 7, 1972. Coach Bob Curtis is fifth from the left. The 1972 team completed the season undefeated for the third time in Franklin & Marshall history.

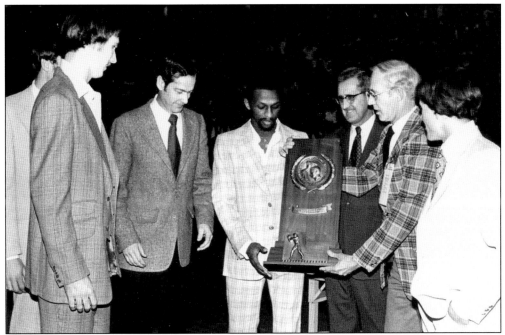

Donnie Marsh, two-time All-American, receives the trophy won by the 1978–1979 men's basketball team, which finished third in the NCAA Division III tournament at Rock Island, Illinois, on March 16 and 17, 1979. Other senior members of the team are Mark Worley and Bill Kane, to the left of coach Glenn Robinson, and Bob Manaskie at the far right.

Williamson medalist Eric Holmboe (left) placed fifth in the NCAA Division III cross-country meet in November 1980. It was the fourth time he had earned All-American honors in that sport. Denise Paull (right) was the first female Franklin & Marshall student to win All-American honors in cross-country, in 1982. Paull accomplished that feat three times. She was also a three-time Middle Atlantic Conference champion and a two-time regional champion.

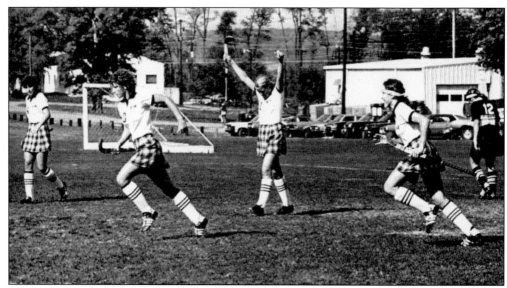

The 1981 field hockey team, coached by Sue Kloss, finished second in the NCAA Division III tournament. Melinda Reuter, Leanne McFalls (1982 All-American), Sandy Swope (1982 All-American), and Donna Zaccaria (1982 and 1983 All-American) celebrate following McFalls's goal, the only score in a tough game against Elizabethtown College on October 10, 1981. The women's lacrosse team also finished second in the 1981 NCAA Division III tournament.

Kathryn "Trink" Prinz, class of 1982, was a four-time All-American in four different events. The first Franklin & Marshall female All-American in swimming, she won the 50-yard backstroke at the NCAA Division III Nationals, held at the University of Massachusetts between March 12 and 14, 1982.

Cheryl McComsey, class of 1982, urges spectators to support the Diplomat football team in the fall of 1980.

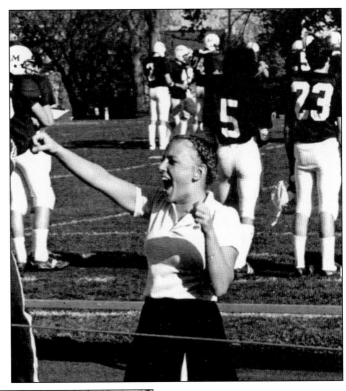

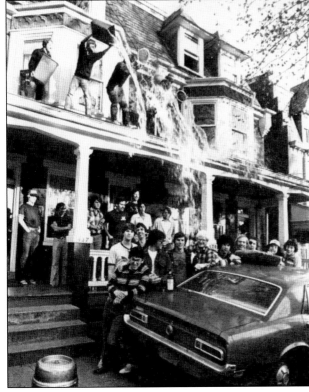

Brothers of the Delta Sigma Phi fraternity surprise their pledges in the spring of 1979.

Director Edward Brubaker (left) and author John Updike talk after the Green Room premier of Updike's play *Buchanan Dying* on April 30, 1976. The play was based on the biography of James Buchanan written by Philip S. Klein, class of 1929. The production was part of the college's celebration of the nation's bicentennial.

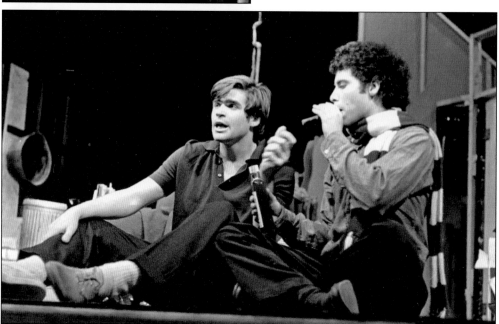

Treat Williams, class of 1973, and Michael Endy, class of 1973, perform in the 1972 Green Room production of *Jimmy Shine*. Williams became a professional actor and starred in film, on stage, and television. Endy, who completed a Master of Fine Arts degree at Catholic University, returned to Franklin & Marshall in February 1977 to direct *The Hot L Baltimore* and again in March 1991 to direct *On the Verge*.

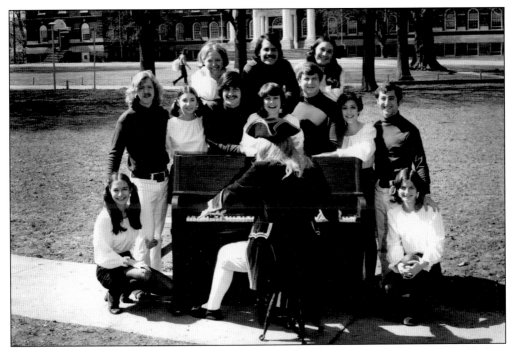

The Poor Richards, the college's singing and dancing troupe, organized in the late 1960s. Following coeducation, the group admitted female performers. In this *c.* 1973 photograph, Hartman Hall appears in the background.

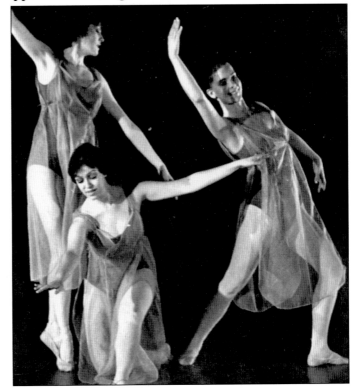

Students Christine Souders, Sue Rappaport, and Beth Haller dance to Johann Strauss's "Blue Danube Waltz" as the opening act for the spring dance concert, on April 7 and 8, 1978.

Linda M. Coleman, class of 1979, dances at an event sponsored by the Black Student Union in the Atrium of the Steinman College Center.

Crystal Greene, Sharon Johnson, Larry Coles (assistant director of student aid and admissions), and Maria Clark attend the reception following Prof. Samuel Allen's Black History Week lecture on W. E. B. DuBois and the role of education in African American history on February 16, 1979.

Maura Condon hands a peppermint stick to Rob Umble at the Spring Arts festival in 1981.

Franklin & Marshall alumni frequently express how important their relationships with faculty have been in their education and their lives. John A. Andrew III, professor of history from 1973 until his death in 2000, exemplified the tradition of excellence in teaching and scholarship at the college. Here, he confers with an advisee, American studies major Carolyn N. Coffee, class of 1982.

Students sled on cafeteria trays in Buchanan Park in February 1978, with the spires of Old Main in the background.

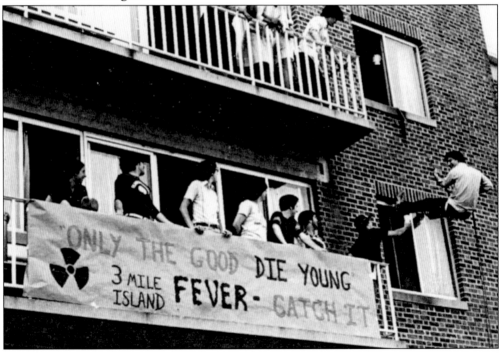

On March 28, 1979, the nuclear power plant at Three Mile Island, 25 miles northwest of Lancaster, became the site of the nation's worst commercial nuclear accident. Two days later, when fear that a hydrogen bubble could result in meltdown, the college closed for what students described as "Nuke Break." The sign on a balcony railing of the Benjamin Franklin Residence Halls expressed students' dark humor about the accident.

Seven

A HISTORIC COLLEGE ENTERS A NEW MILLENNIUM 1983–2004

The years since 1983 have been a period of enormous growth at the college. Four important new buildings were added—the Martin Library of the Sciences, Weis Hall, the Alumni Sports and Fitness Center, and the Roschel Performing Arts Center. The college made other strides in facilities for the fine arts through the creation of the Phillips Museum of Art and the renovation of Hensel Hall to house the Ann and Richard Barshinger Center for Musical Arts. The college also undertook major renovations to the William M. Hackman Physical Science Laboratories.

During these decades, the curriculum became much more interdisciplinary. New majors—such as Africana studies, biochemistry and molecular biology, biological foundations of behavior, music, and scientific and philosophical studies of the mind—as well as a number of new minor programs broadened and deepened the educational opportunities for students. The college introduced a new general education curriculum that required students to take nondepartmental, interdisciplinary courses in three areas: community, culture, and society; mind, self, and spirit; and the natural world.

With the shift to a 3-2 teaching load, faculty were able to increase significantly the number of independent study and tutorial opportunities for students, and the Hackman Scholars program allowed 60 students each summer to undertake collaborative research with faculty. In 2003, the Princeton Review's *The Best 351 Colleges* rated Franklin & Marshall best in the nation for the accessibility of its faculty.

While students continued to engage in sports and an array of organizations, the campus changed in two principal ways. First, the internationalization of the student body brought new perspectives and cultures that enriched the lives of all. Second, students demonstrated a renewed commitment to public service. The campus Habitat for Humanity chapter organized in 1988, and other service organizations tackled pressing social needs in Lancaster and around the world. For example, on June 25, 1998, Pres. Richard Kneedler presented to Rev. Leon Sullivan a check for $10,000, contributed by students, faculty, staff, and administrators, to build a school in Africa. In 2003, Pres. John Fry proposed the goal that Franklin & Marshall be the most civically engaged campus in the United States.

Franklin & Marshall entered the new millennium a healthy, vibrant college committed "to foster in its students qualities of intellect, creativity, and character, that they may live fulfilling lives and contribute meaningfully to their occupations, their communities, and their world."

Richard Kneedler, class of 1965, became the 13th president of the college in 1988, succeeding James L. Powell, who had served since 1983. Kneedler led the college through the most successful capital campaign in its history, oversaw the construction of four new buildings, the renovation of several others, and the creation of the Arts Quadrangle. In 2003, the college dedicated the Richard Kneedler Sculpture Garden in his honor. (Photograph from the *Lancaster New Era*; courtesy of Lancaster Newspapers Inc.)

John A. Fry, an alumnus of Lafayette College, was inaugurated as the 14th president of the college on April 12, 2003. He had worked in higher education consulting until he was appointed executive vice president of the University of Pennsylvania in 1995. As Franklin & Marshall president, Fry has launched an ambitious strategic planning process, initiated the preparation of a campus master plan, and built important links between the college and the Lancaster community.

William H. Gray III, class of 1963, speaks during commencement exercises on May 18, 1986, when he received an honorary doctor of laws degree. In his address, Gray, then chair of the House Budget Committee, decried the "growing sea of red ink" resulting from Reagan administration policies. A trustee of the college, he established the William H. Gray Jr. Scholarship for students from groups traditionally underrepresented in higher education.

Mary Schapiro, class of 1977, addresses graduates during the May 21, 1995, commencement, in which she was given an honorary doctor of laws degree. Schapiro, former chair of the Commodity Futures Trading Commission, is currently the president of NASD Regulation. She urged students to "put your heart into whatever you do" and to "see life in all its hues, not just black and white." Schapiro was elected to the college's board of trustees in 1999.

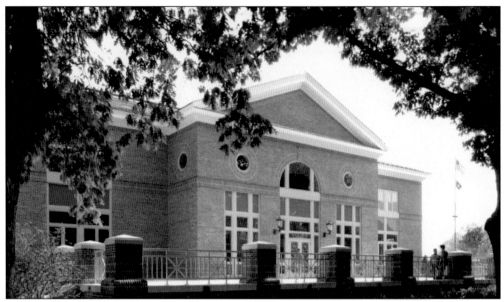

Martin Library of the Sciences, designed by Shepley, Bulfinch, Richardson & Abbott, was dedicated in honor of former president of the board of trustees Aaron J. Martin, class of 1950, and Jean Truxal Martin on April 12, 1991.

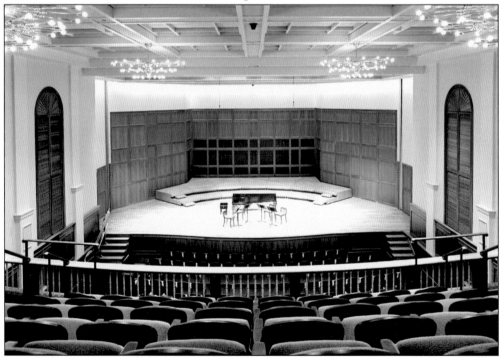

The Ann and Richard Barshinger Center for Musical Arts in Hensel Hall was dedicated on March 25, 2000. Boston architectural firm Ann Beha & Associates and acoustical consultants Kirkegaard Associates transformed the 800-seat Hensel Auditorium into a state-of-the-art concert hall that, with the addition of a balcony, seats 500. (Photograph by Lori Stahl.)

The Roschel Performing Arts Center, named in honor of Robert L. Roschel, M.D., class of 1954, was dedicated during the weekend of October 24–26, 2003. Designed by R. M. Kliment and Frances Halsband, with Sachs Morgan Studio theater consultants, it contains a 302-seat theater, two dance studios, and a media teaching lab, as well as support facilities for the Department of Theater, Dance, and Film.

Robert L. Roschel speaks at the dedication of the Roschel Performing Arts Center. Roschel starred in the role of John in the November 1950 Green Room production of *Dark of the Moon.* Also addressing the convocation were professor of drama emeritus Edward Brubaker, class of 1949; actor Roy Scheider, class of 1955; and choreographer Glen Tetley, class of 1946. (Photograph by Jose Urdaneta.)

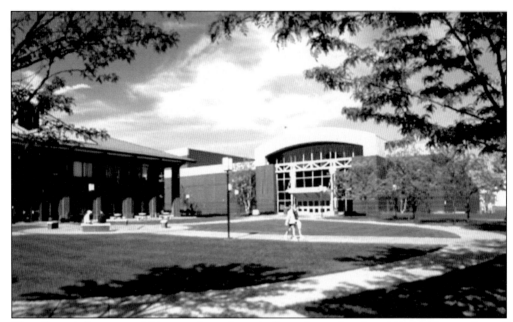

The Alumni Sports and Fitness Complex, dedicated on October 27, 1995, consists of the Schnader Field House, an all-purpose athletic facility; Poorbaugh Aerobics Center; Kunkel Aquatic Center and George McGinness Pool; several offices and equipment rooms; and the Woods Memorial Room, a multi-functional meeting space. In addition to athletics, the Schnader Field House is the site for major college and community events. College Square is to the left.

Benjamin Franklin leads the Spirit Parade to Williamson Field during homecoming festivities on October 2, 1999.

Morris Clothier (left), class of 1987; Scott Brehman (center), class of 1985; and Chris Spahr, class of 1987, were named All-Americans in squash in 1985. Clothier, a four-time All-American, and Spahr, a three-time All-American, led the 1987 team to a second-place ranking in the nation.

Lee Belknap, class of 1991, was a four-time squash All-American. At the conclusion of the Howe Cup, the U.S. Women's Intercollegiate Squash Racquet Association presented her with the Betty Richey Award for Sportsmanship, its highest honor. Belknap led the team to a fifth-place finish at the Howe Cup, the women's national championship, played at Yale the weekend of February 15–17, 1991.

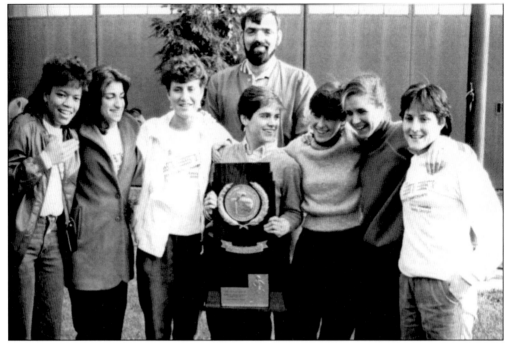

The 1985 women's cross-country team captured the Division III national championship. Standing from left to right are Terry Smith, Lois Lucente, Laurie Reynolds, Katrina Harriman (holding the NCAA trophy), Amanda Shaw, Nancy Leet, and Dee Dee Hemingway. Coach Ed Woge stands behind his team. Lucente and Shaw earned All-American honors.

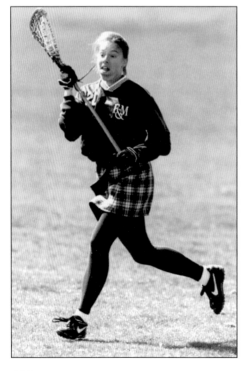

Sarah Reigner, class of 1999, was named Centennial Conference Player of the Year and first-team All-American in 1999. A Dana scholar and Hackman scholar, she was also honored as an academic All-American.

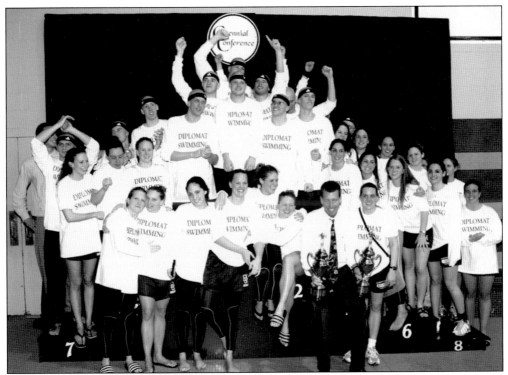

The men's and women's swimming teams, coached by Bob Rueppel, captured Centennial Conference championships in 2004. It was the first women's championship and the first time in Franklin & Marshall history that both the men's and women's teams in any sport captured championships in the same year.

Three-time national champion and six-time All-American Krystle Satrum, swimming in McGinness Pool, holds the NCAA Division III record for the women's 200-yard backstroke.

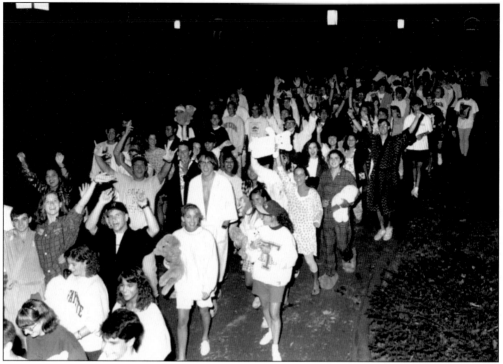

The Pajama Parade, a rite of initiation for first-year students in the years between the world wars, was revived in the 1980s. This photograph captures the class of 1996 marching from Old Main toward College Avenue in August 1992.

Michelle Altman, class of 2006, moves into her dormitory room on the first floor of Schnader Hall in August 2002.

These unidentified students use first-generation Macintosh computers in the computer classroom in the basement of Apple Infirmary c. 1985.

Ismat Dewji (right), class of 2004, taking advantage of wireless technology, works on her laptop on Hartman Green in 2001. Serli Guleryuz, class of 2005, is at the left.

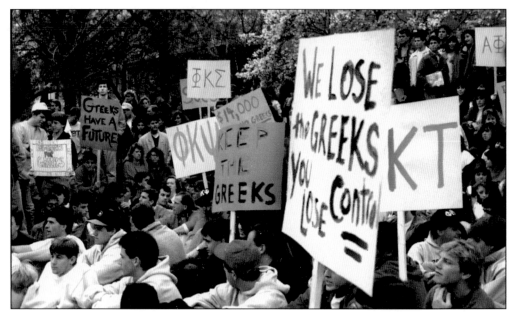

Students protested the decision to withdraw recognition of fraternities and sororities. On March 24, 1988, the faculty adopted a resolution declaring that the Greek system was "inimical to the goals of liberal education." On April 13, 1988, the board of trustees accepted the recommendation of the Trustee Committee on Student Life and formally withdrew recognition, which sparked the student protest. In 2004, the faculty and trustees voted to re-recognize the Greek system.

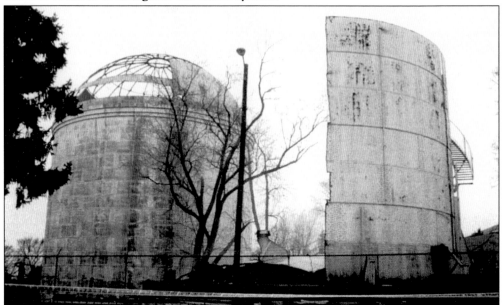

The water towers in Buchanan Park were constructed in 1925 and 1932 to increase water pressure in homes in the city's west end. Students referred to the older structure, with its pointed top, as George, and the second tower, with its round dome, as Martha. The water towers became obsolete when Lancaster began drawing its water supply from the Susquehanna River during the 1950s, and were demolished in 1996.

Sisters of Alpha Phi, the college's second sorority, participate in Our Neighbors Ourselves, an annual volunteer community service program, in October 1989.

In September 1988, Franklin & Marshall students traveled to Atlanta to receive a charter from Habitat for Humanity founder Millard Fuller and spokesperson Jimmy Carter for a campus chapter of the organization. During spring break in March 2003, students traveled to Hickory, North Carolina, for the Collegiate Challenge (seen here), where they built a house in one week.

This sculpture, composed of glass panels with metal frames, was erected in the Richard Kneedler Sculpture Garden. The panels, with quotations about war and peace from Benjamin Franklin and John Marshall sandblasted on the glass, were created by students in Prof. Virginia Maksymowicz's first-year seminar, How Ideas Become Form, during the fall semester of 2002. (Photograph by Marcy Dubroff.)

Michael Yashinski (left), class of 2004, and Nana Aba Mensah-Brown, class of 2006, rehearse their roles in *King Lear,* the inaugural Green Room production in Schnader Theater, Roschel Performing Arts Center, directed by Prof. Donald McManus. (Photograph by Marcy Dubroff.)

Dharmi Dinesh Kotak, class of 1996, dances in classical Indian dress *c.* 1995. (Photograph by Dan Marschka.)

The Venerable Losang Samten, a Tibetan Buddhist teacher, creates a sand mandala in the Curriculum Gallery, Phillips Museum of Art, in October 2003. A mandala is a diagrammatic representation of the cosmos. (Photograph by Marcy Dubroff.)

Kenneth Duberstein, class of 1965, speaks on the 1984 election in the Atrium, Steinman College Center, on October 9, 1984. A highly respected consultant and political commentator, he served as assistant to the president for legislative affairs and as White House chief of staff during the Reagan administration. Elected to the board of trustees in 1986, Duberstein received an honorary doctor of laws degree at the 1989 commencement.

Shown is Richard D. Winters (right), class of 1941, whose diaries of his experiences while leading Easy Company during World War II were featured in Stephen E. Ambrose's *Band of Brothers* and in an HBO miniseries of the same title co-produced by Steven Spielberg and Tom Hanks. Winters, speaking with Christopher Kelly, class of 1979, received the college's Alumni Citation on October 24, 2003. (Photograph by Marcy Dubroff.)

Franklin & Marshall celebrated the bicentennial of the establishment of Franklin College and the drafting of the U.S. Constitution over a 10-month period beginning with a convocation on January 17, 1987. Events included an exhibition on the history of the college prepared by Prof. Louise Stevenson's American studies seminar; the production of *Benjamin*, an opera composed by Prof. John Carbon with libretto by Prof. Sarah White; and an array of speakers, concerts, and other events. A highlight of the year was the Founders Day celebration on June 6, 1987, when trustees, faculty, administrators, alumni, and civic leaders processed down North Prince Street (above) and east on King Street (below) to Trinity Lutheran Church to celebrate the founding convocation that had taken place there two centuries earlier.

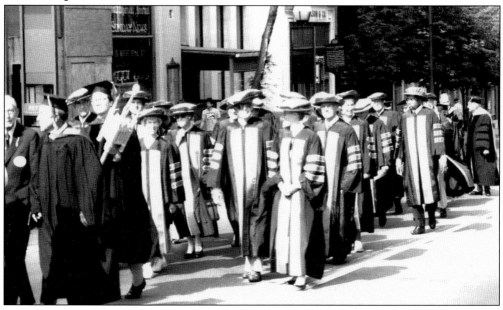

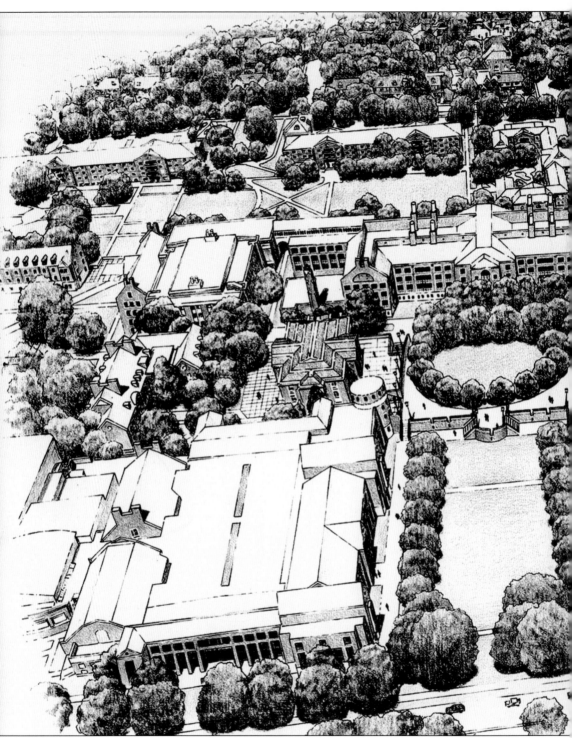

This sketch, prepared by Baltimore architects Ayres/Saint/Gross, shows the expansion of the campus to the north advocated in the 2004 Campus Master Plan. To the right, across Harrisburg Pike, is a College Town development of retail and apartments. South